Rembrandt and the Venetian Influence

Rembrandt and the Venetian Influence

Essays by Sir Kenneth Clark,

Frederick Ilchman, and David Rosand

Salander-O'Reilly Galleries

NEW YORK

This catalogue accompanies an exhibition from
October 3 to November 18, 2000 at

Salander-O'Reilly Galleries, LLC
20 East 79 Street New York, NY 10021
Tel (212) 879-6606 Fax (212) 744-0655
www.salander.com
Gallery hours: Monday–Saturday 9:30 to 5:30

TABLE OF CONTENTS

ACKNOWLEDGEMENTS

This exhibition would not have been possible without the participation of the following friends, colleagues and generous lenders. We are grateful for their support.

Piero Corsini; Margaret Hanbury; Frederick Ilchman; Jon and Barbara Landau; The Metropolitan Museum of Art, Philippe de Montebello, Director, Everett Fahy, John Pope-Hennessy Chairman of European Paintings, Keith Christiansen, Jane Wrightsman Curator, Walter Liedtke, Curator; The Nelson-Atkins Museum of Art, Marc Wilson, Director, Roger Ward, Curator of European Paintings and Sculpture; Anne and Martin Peretz; Philadelphia Museum of Art, Anne d'Harnoncourt, Director, Joseph Rishel, Curator of European Paintings; The John and Mable Ringling Museum of Art, Mitchell Merling, Curator of European Art before 1900; David Rosand; The Fine Arts Museums of San Francisco, Harry Parker, III, Director, Stephen A. Nash, Associate Director and Chief Curator, Lynn Orr, Curator of European Paintings; Martin Zimet.

Thanks to the executors of the estate of the late Lord Clark of Saltwood for permitting us to reprint *Rembrandt and the Venetians*.

By Lawrence B. Salander

SOMEHOW over the course of time it has become pejorative in the discussion of art to be influenced. The new, which is a much different concept than the original, has it seems become the end-all and be-all of much of what is being taken seriously. That is indeed if any art is taken seriously today except for the huge amount of money changing hands around it. It seems as if it would be better business today for an artist to make work that is fashionable rather than serious.

The fact is that over the centuries all great art was original and very little of it was new. Originality is the result of the combination of integrity and individuality. This can and has been proven over the years if, for example, we examine copies made by one artist of another artist's work. It has been my experience that these copies, subject matter aside, often are highly original creations.

There is a continuum in the creative process which involves artists learning and improving through the study of great art that came before them. This holds true no matter how great an artist is, and it is without exception. This fact is illustrated here by the influence of Titian, and through him Tintoretto, on the art of Rembrandt. Rembrandt, who never traveled to Italy, was in a unique position to see the work of these great Venetian and other Italian painters by virtue of the fact that Amsterdam was the center of the mid-17th century commercial world, and great art collections including masterpieces of Italian painting were dispersed there in Rembrandt's time. Thus it was in Amsterdam where Rembrandt actually pursued looking at and purchasing Italian works of art. He saw the works of many great Renaissance artists, including Raphael and Titian, and he took from them. It made him, as great as he was before, a much greater painter. My observation is that this process of change in his paintings started for Rembrandt around 1638 or 1639. It is interesting to note that his etchings are in advance of his paintings as it relates to the appearance of a late style. It is as if his personal intuitions, worked out in the privacy and intimacy of his print shop, were vetted by the great Italian paintings he saw coming through Amsterdam. That freed him up to take the ultimate and in his case financially costly risk of changing his oil paintings for the better in public.

The influence of Titian on Rembrandt is a well known art-historical fact. I believe Tintoretto's was less direct. This stems from the idea that even though Titian was older then Tintoretto (who studied with him for a short while), Titian's late style was influenced by the mature work of the younger man. And it was the later paintings of Titian that pointed the way for Rembrandt. This would not be the first or the last time a student influenced his teacher in art. For example both Titian's teacher Giovanni Bellini and Titian himself were influenced by Bellini's student and Titian's colleague Giorgione.

The purpose of this exhibition is to illustrate that even at the highest level of art making in history, artists have looked hard at other artists' work and taken what they needed to improve. It was expected and encouraged and it should continue to be.

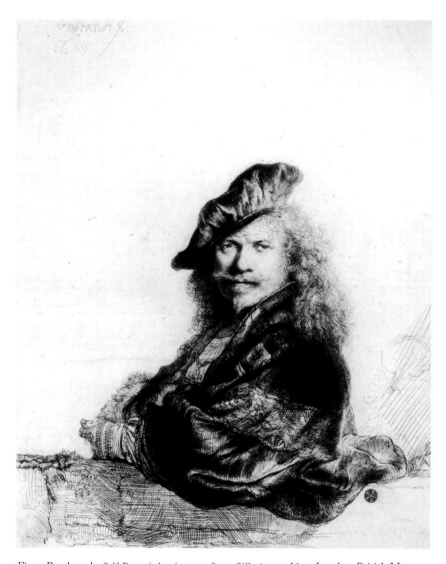

Fig. 1. Rembrandt. *Self-Portrait leaning on a Stone Sill*, 1639, etching. London, British Museum

Titian's Dutch Disciple

By David Rosand

Now, although many have been with Titian in order to learn, the number of those who can truly be called his disciples is not great; that is because he did not teach much, but each one learned more or less what he could from the works executed by Titian.

—Giorgio Vasari (1568)

The touch is so difficult to see in his work, the hand of the craftsman so completely concealed, that the steps he took to arrive at such perfection remain a mystery. There still exist underpaintings from pictures by Titian. . . . But I do not think that any of these underpaintings can give us a clue to the methods which Titian used in order to bring them to that always consistent style so remarkable in his finished works.

—Eugène Delacroix (1857)

IN THE EARLIEST critical comment on Rembrandt, written between 1629 and 1631, Constantijn Huygens praised the miller's son and his Leiden colleague Jan Lievens, son of an embroiderer. The distinguished secretary to the stadholder Prince Frederick Henry hailed these young painters of common stock as proof that creative talent transcends nobility of birth. Singling out Rembrandt's special achievement in the expression of lively emotion, Huygens offered a responsive reading of the painting of Judas Returning the Thirty Pieces of Silver (BR. 539A*); he focused on the intensely penitent gesture of Judas, in which "this miller without a beard" created a figure of such passionate complexity that it rivaled the achievements of the ancients. "Italy has been brought to Holland by this Dutchman, who till now has seldom left the confines of his city."

And yet, Huygens, the schooled humanist, could not but lament such parochialism, that these still beardless talents refused to visit Italy to gain further inspiration from the great works of Raphael and Michelange-lo. The response of the two youngsters was that they were too busy trying to establish their own careers and had no time to waste in travel. Besides, they insisted, such travel was hardly necessary, for Italian paintings were coming north in great numbers. And so they were.

Thriving Amsterdam had indeed become a major art emporium. Rembrandt moved there in 1631, having already invested in the art-dealership of Hendrick Uylenburgh, his future cousin-in-law. Uylenburgh's enterprise was a complex one, involving commerce in old and new art, including works by Uylenburgh himself as well as by Rembrandt and their assistants; the firm also engaged in publishing and selling prints, offering art lessons, and appraising works of art. In Amsterdam the young man from Leiden quickly became the most fashionable portrait painter in town, and his success allowed him to deepen his investment in the art market. As an avid collector himself of works of art and other curiosities, Rembrandt eventually overextended himself financially. His heavy borrowing led to an application for a declaration of bankruptcy in 1656, and the inventory of his possessions drawn up on this occasion proves particularly revealing. Italy had indeed come to Rembrandt.

The sheer range of objects inventoried attests to a collection that went beyond the usual paraphernalia of an artist's studio and aspired to the encyclopedic coverage of an ambitious *Wunderkammer*—classical portrait busts and other antique sculptures or casts thereof, coins and medals, arms and armor, musical instruments, as well as animal skins, shells, coral branches, and "many other rarities." Above all, however, the inventory featured works of art, paintings, drawings, and prints that testify to Rembrandt's intimate knowledge of the history of Renaissance art throughout Europe; one large album, for example, was "filled with drawings by the leading masters of the entire world." Among the Italians are listed paintings ascribed to Raphael, Giorgione, Palma Vecchio, Jacopo Bassano, as well as copies after Annibale Carracci. Of the many albums of prints after the major masters of the Renaissance, one item is of

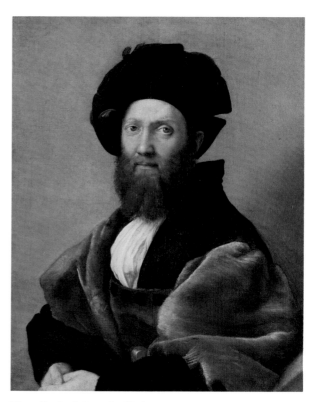

Fig. 2. Rembrandt. *Drawing after Raphael's Portrait of Baldesar Castiglione* (detail), 1639. Vienna, Graphische Sammlung Albertina

Fig. 3. Raphael. *Portrait of Baldesar Castiglione*, ca. 1514-15. Oil on wood, transferred to canvas, 32¼ x 30 in. Paris, Musée du Louvre

special interest to us: "a very large album with almost all the work of Titian."

This would have been a collection of prints after the Venetian master's designs, woodcuts, engravings after his paintings, etchings after drawings. Moreover, Rembrandt himself presumably owned and copied drawings by Titian. For direct knowledge of Titian's paintings, however, he relied on the traffic of the Amsterdam art market, which did indeed bring Italy to Holland.

A most precious document of Rembrandt's participation in that traffic is a drawing made on April 9, 1639, when he attended the sale of the art collection of Lucas van Uffelen (fig. 2). Recording what was presumably the star item of the sale, Raphael's *Portrait of Baldesar Castiglione* (fig. 3), Rembrandt quickly sketched the image, automatically adding a Baroque dynamic to the Renaissance composure of the model; he also noted that it sold for 3500 guilders. The successful bidder was Alfonso Lopez, a converted Portuguese Jew, resident in Amsterdam in 1638-1641. Lopez was a dealer in textiles and diamonds and other, non-luxury items, whose collection of

art included at least two other paintings that were to make strong impressions on Rembrandt; both were by Titian: an image of Flora (fig. 4) and a portrait of a man that was then, significantly, considered to be of the great Italian Renaissance poet Ludovico Ariosto (fig. 5).

Although quite well established as a master portraitist, in these two Italian effigies Rembrandt found new inspiration, models for refashioning his own self-image. Peter Paul Rubens had already brought north the values of an Italian Renaissance tradition of the noble painter, a status most famously achieved by Titian himself. The Venetian painter had been knighted by the emperor Charles V, and the patent of nobility had compared the relationship between imperial patron and his painter to that of Alexander the Great and his painter, Apelles, the most celebrated of antiquity. Titian came to stand for the highest professional and social aspirations of the artist, and in the early seventeenth century no artist came closer to equalling that achievement than Rubens. Rembrandt, the miller's son, was keenly aware of the example set by his older, courtly Flemish contemporary.

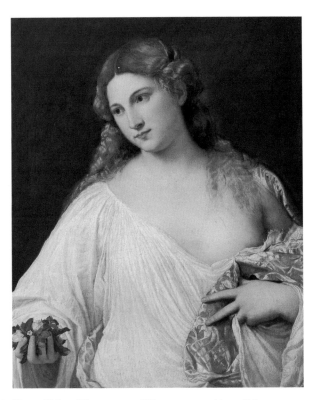

Fig. 4. Titian. *Flora*, ca. 1520. Oil on canvas, 31⅛ x 24¾ in. Florence, Galleria degli Uffizi

Fig. 5. Titian. *Portrait of a Man (so-called "Ariosto")*, ca. 1512. Oil on canvas, 32 x 26⅛ in. London, National Gallery

The Italian portraits he encountered in Amsterdam, then, put the Dutch master into direct pictorial contact with that tradition, with a pose, an attitude that conveyed a social self-confidence on the part of the sitter as well as a correspondingly sophisticated self-awareness of aesthetic structure. And Rembrandt put this experience to use immediately, first in an etched self-portrait of 1639 (fig. 5). From the contrapposto of Titian's *"Ariosto"*, the face turning toward the viewer from a body in profile, he developed the even more radical torsion of his own pose, turning his head completely frontal—while retaining the rakish angle of the beret that came so naturally to his pen in the sketch of Raphael's *Castiglione*. But it was especially the motif of the sleeve overlapping the ledge that offered a particular pictorial challenge. Identifying with the frame and, therefore, the picture plane, the parapet functioned as both base for the sitter and ostensible frontier between illusion and reality. Breaking across that threshold, the sleeve—like the gaze itself of the sitter—establishes a physical link between the two worlds, a functional ambiguity long exploited in painting, and especially in

portraiture. Furthermore, the motif of the jutting elbow had become a favorite expressive gesture in portraiture, including Rembrandt's own, a means for the sitter to assert claim to personal space. In Titian's *"Ariosto"* the incident of overlap is subtly muted. Rembrandt's etching needle activates it into a more dynamic motif; draperies and shadow add further weight to the extended elbow, carrying forward the shoulder to transform the calm self-assurance of his Venetian model into a state of agitation—a state fully consonant with the nervous linework that defines the forms.

The following year Rembrandt monumentalized and modulated his graphic self-portrait in a painting that paid tribute to both Titian and Raphael (fig. 6). Adjusting the tilt of his floppy cap, he sought to regain some of the composure of his Italian models. Whereas in the etching the parapet had sacrificed some of its foundational function to the more open linear network of the image and its floating vignette quality, in the painting it reasserts that function with new pictorial authority, affording a firmer base for the overhang of elbow and sleeve. In painting that complex garment,

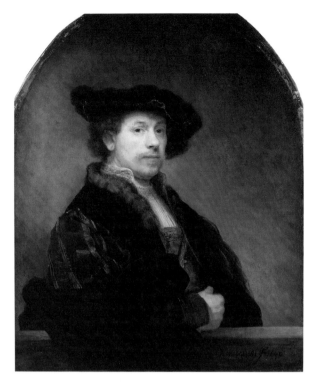

Fig. 6. Rembrandt, *Self-Portrait*, 1640. Oil on canvas, 40⅛ x 31½ in. London, National Gallery

Rembrandt seems to be responding at once to the silken splendor of Titian's sleeve and to the subdued sophistication of Raphael's sartorial palette. In general, then, Rembrandt here presents himself under firmer control, his body more erect than in the etching. Still dressing himself in expensive costumes of the Renaissance past, he now carries his body with a certain dignity and reserve, proving himself a worthy heir of that tradition—a Titian *redivivus*.

Flora, the other Titian painting in the Lopez collection, also had an impact upon Rembrandt. He had already been rendering his young wife Saskia in the guise of a Batavian Flora, dressed in Arcadian costume, her full figure showing her pregnant, in 1634 (St. Petersburg, The Hermitage [BR. 102]), or, the following year, sustaining an abundant bouquet of flowers (London, National Gallery [BR. 103]). Evidently inspired by Titian's picture, he again represented her in 1641 (the year before her death), more modestly, one hand to her breast in a gesture of devotion, the other offering a single flower to the viewer (fig. 7). The overtly erotic appeal of Titian's wanton goddess has in effect been domesticated; the intimate deshabille of the Venetian

courtesan has been decorously covered, the blatant offering of the body substituted by the trusting openness of Saskia's gaze.

The memory of Titian's *Flora* remained with Rembrandt. Years later, about 1655, he renewed his pictorial meditations on the theme when he posed as the floral goddess the woman who eventually replaced Saskia in his life, Hendrickje Stoffels (see plate x). In this representation, however, while the body continues to address itself directly to the viewer, gaze and gesture turn away sharply, set in profile. The frontality of pose offers the body, or rather the costume, as a field essentially parallel to the picture plane. And these two planes—the actual canvas support and the fictive body—tend to merge in and through the act of painting; it is as though the painter, in applying pigment, was actually brushing the white chemise of his Flora. The model may no longer engage in dialogue with us, but she does present her body to the viewer's attention; the viewer was, of course, in the first instance, her creator, the painter himself.

Saskia offering a flower spoke to and moved toward Rembrandt, and now moves toward us; she carries the fullness of her body forward. Painted on wood

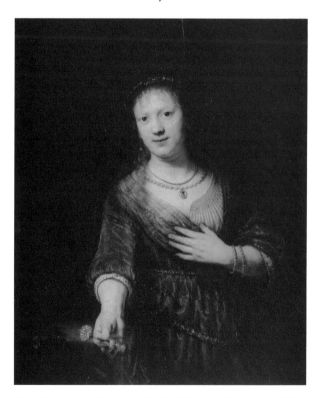

Fig. 7. Rembrandt. *Portrait of Saskia Offering a Flower*, 1641. Oil on wood, 38¾ x 32½ in. Dresden, Staatliche Kunstsammlungen

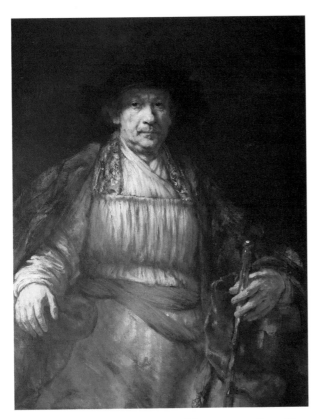

Fig. 8. Rembrandt. *Self-Portrait*, 1658. Oil on canvas, 52⅝ x 40⅞ in. New York, The Frick Collection

1653, also in the Metropolitan Museum. Paint identifies at once as imitated substance and as its own substantial self, and in that dynamic ambivalence lies the particular aesthetic appeal of Rembrandt's *Flora*. That shifting reference is enabled by the frontality of address, which collapses the planes of figure and canvas.

Such frontality is characteristic of Rembrandt's later style, especially in this decade. "Breadth and squareness of execution" marks every aspect of his art, drawing and etching as well as painting. By the 1650s Rembrandt abandoned the rounded volumes and curvilinearity of the Baroque for a manner that, for its very reductiveness, might be termed archaic rather than classical. These qualities—of geometric simplicity, of rectilinearity and frontality—inform every choice in paintings such as the monumental *Self-Portrait* of 1658 in the Frick Collection (fig. 8) and the later *Juno*, of about 1665, in the Armand Hammer Collection (fig. 9). In each of these images the pose itself fills the field, offering a broad expanse of painted surface. And each, in a different way, returns us to Rembrandt's relation to a Venetian tradition.

panel, her image is a rich blend of delicately molded impasto and glazed color; the surface is worked in detail, built up to articulate the decorative textures of the costume, the end of the brush dragged through wet paint to create patterns of embroidered lace. Technique is clearly in the service of illusion. In the later *Flora*, although the ultimate goal remains mimetic, the relationship seems reversed: here illusion cedes priority to paint. Rembrandt's brush is broader, his application of paint rougher, and he relies upon that roughness for effect, a certain "breadth and squareness of execution"— in the words of John Smith, author of an early nineteenth-century catalogue of the artist's work.

At the core of the image are planes of paint, especially the sequence of vertical strokes that become the folds of blouse, depending from and suggestively defining the body that they clothe. Brush stroke identifies as garment, its shifting direction and tighter concentration modulating with the shift from broad torso to folds of bunched sleeve—comparable to the impasto dynamic of the sleeves in *Aristotle with a Bust of Homer* (BR. 478), of

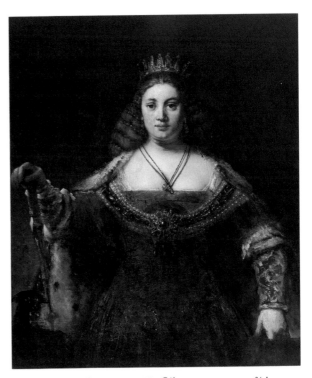

Fig. 9. Rembrandt. *Juno*, ca. 1665. Oil on canvas, 50 x 42⅜ in. Los Angeles, The Armand Hammer Collection, UCLA, at the Armand Hammer Museum of Art and Cultural Center

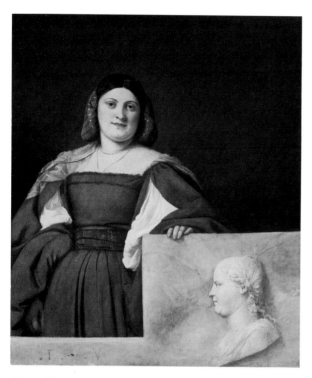

Fig. 10. Titian. *Portrait of a Woman (so-called "La Schiavona"),* ca. 1511–12. Oil on canvas, 47 x 38 in. London, National Gallery

The *Juno* is "a striking example of Rembrandt's interest during the late period of his life in the normative aspects of Venetian portraiture," as Julius Held observed in a fundamental study of the painting. By "normative aspects" Held was alluding to a generic type of Venetian frontal female portrait—by Paris Bordon or Bonifazio de' Pitati. Less obviously but quite appropriately, however, he cited Titian's portrait of a woman known as *La Schiavona* (fig. 10). This early work by Titian, of about 1511, is not likely to have been known to Rembrandt, but it does remind us of an important constant in the Venetian's style, its essential classicism. Titian's style, from early in his career, is marked by a fundamental awareness of and respect for the picture plane—epitomized in the frequent invention of relief sculptures in his paintings, as in *La Schiavona*. That awareness proved a fundamental preparation and prerequisite for the remarkable development of Titian's late style, a manner of painting that is central to our theme.

This involves the exploitation of the material substance of oil paint and the physical presence of the artist in his work, so richly manifested in Rembrandt's Frick *Self-Portrait*. Painted at a time of personal crisis, only

two years after his bankruptcy, this canvas confronts the world as a triumphal declaration of Rembrandt the artist. Posed with imperial confidence, his bulk filling and dominating the field, Rembrandt offers himself as a pictorial surface. As in the Flora but with greater complexity, brushwork simultaneously structures the body and the painting, as Rembrandt creates a painted wall of himself. Indeed, painting and body fuse even more literally, for we discern the mark of the artist's fingers moving directly through the paint, reshaping the strokes of the brush—for example, in the knuckles of his sceptred hand. Just about a century earlier Titian had comparably presented himself through the art of his brush, in the assertively confident *Self-Portrait* in Berlin (fig. 11). Here too prominence is accorded the strong hands of the creator.

Against the assertive presence of Rembrandt's body, the shadowing of the eyes withdraws presence, luring us into a barely perceptible psychological realm, inviting us to project our own imagination as we seek to read this face. This is an affective mechanism that recalls the evocative aesthetic of earlier Venetian painting, the suggestive poetry of Giorgione, which was then given more heroic expression by his disciple Titian. The subjectivity of poetic suggestion found its pictorial means through the open brushwork of Venetian painting, the tactility of which invited a corresponding projection of the senses.

Giorgione had revolutionized the art of oil painting in the years immediately after 1500. In the previous century that art, following the lead of early Netherlandish masters like Jan van Eyck, had developed as a technique of translucent glazes of color applied to a basically light gesso ground of a prepared wood panel. In Venice the technique was explored to richest effect by Giovanni Bellini. It was also in Venice that an alternative method of painting developed, using canvas as a support: first as a substitute for fresco—in a city built upon water, where constant humidity frustrated the proper setting of plaster—and then as an alternative to wood. Exploiting two material aspects of the art, the woven surface of the canvas and the impasto possibilities of oil paint itself, opaque rather than translucent, Giorgione effectively laid the foundation for the subsequent history of Western painting. Working directly upon the canvas, he constructed his paintings not in

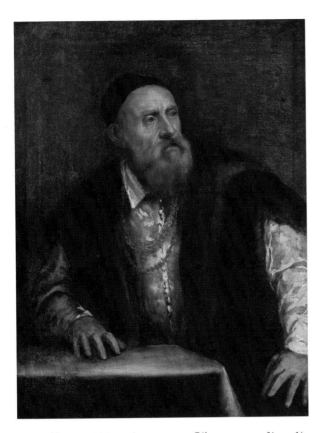

Fig. 11. Titian. *Self-Portrait*, ca. 1550–55. Oil on canvas, 37¾ x 29½ in. Berlin, Staatliche Museen, Gemäldegalerie

the traditional sequence of translucent layers, which allowed light to penetrate to and reflect off the white gesso ground—the source of the internal illumination glowing from within paintings in the Eyckian tradition, such as Bellini's *St. Francis* in the Frick Collection. Rather, Giorgione prepared his pigments with greater density, building light upon dark, so that illuminated forms emerged from shadowed ambience. He developed a technique that allowed him to revise a painting in progress, to cancel a form by covering it over with a new layer of opaque paint. These innovations were inherited by his most celebrated disciple, who continued to explore the potential of the medium.

Actually, Titian's early work retains much of the more finished manner practiced by his previous master, Giovanni Bellini. Only later in his career did he begin to realize the fuller implications of Giorgione's legacy. The distinction between his earlier and later manners was recognized by the keen critical eye of Giorgio Vasari, author of the most influential art history ever

published, *The Lives of the Most Excellent Painters, Sculptors, and Architects*. Only in the second edition, of 1568, did Vasari include a biography of Titian. Overcoming his Tuscan bias, which valued clarity of contour as the foundation of painting, Vasari responded to the challenge of Titian's open brushwork:

> . . . it is quite true that his method in these later works is rather different from that of his youth: his early paintings are executed with a certain fineness and incredible diligence and can be viewed both from up close and from afar; these recent works, on the other hand, are carried out in bold strokes, broadly applied in great patches [*macchie*] in such a manner that they cannot be looked at closely but from a distance appear perfect. And this method has been the reason that many, wishing to imitate Titian and so demonstrate their own ability, have only produced clumsy pictures. This happens because they think that such paintings are done without effort, but such is not the case and they delude themselves; for Titian's pictures are often repainted, gone over and retouched repeatedly, so that the work involved is evident. Carried out in this way, the method is judicious, beautiful, and magnificent, because the pictures seem to come alive and are executed with great skill, hiding the effort that went into them.

A generation later Vasari's observations were extended to the Netherlands, in Karel van Mander's book on painting and painters, *Het Schilder-boeck* (1604). Van Mander makes the same distinction, between a finished or smooth (*net*) style and one that is rough (*rouw*). The assumption is that a painter should first master the controlled techniques required for the finished manner and only later allow himself the liberties of the rougher mode. Indeed, standard pedagogic practice would have mandated such a sequence, for an apprentice naturally began his artistic education by drawing. Rembrandt's own early work respects the standards of a smooth style, although we sense from the beginning a certain energy of application, an impatience even, that in its mimetic drive, its search for painted correlatives to the textures of reality, seems intent upon marking up the finished surface.

Vasari's comment that Titian's painting concealed the effort that went into it suggests a larger cultural context for comprehending this bold demonstration of the brush. Artistic performance could be considered, beyond the studio, as a gauge of social accomplishment, the display of brilliant brushwork a mark of social as well as professional control: the art that hides art, that makes the difficult appear easy, the artificial natural. Such values reflected the language of the courtier, as it was articulated in Castiglione's *Book of the Courtier* (1528), where the neologism *sprezzatura* was coined as a term for such easy nonchalance. The knowing stroke of the painter's brush became the overt mark of his skill, and the appreciation of such a mark testified to a connoisseur's sensitivity—the ability to recognize the art in a single, unforced line, as Castiglione phrases it (*una linea sola non stentata*).

In the sixteenth century Italian aesthetic response came increasingly to appreciate the open work. Leonardo da Vinci was the first to celebrate the sketch as an organic, evolving form of expression, a challenge to perception and interpretation. As Vasari subsequently elaborated, the rapid sketch takes us closer to the moment of inspiration than does the finished painting, closer to the creative imagination of the artist. In this light, the unfinished work came to acquire new value, its still rough surfaces revealing the processes of its becoming: Michelangelo's tormented prisoners for the tomb of Julius II, for example, or the canvases abandoned in Titian's studio at his death. And through such revelation the sensitive viewer was that much closer to the creator of the work.

The very personal identity of the painter with his brush is explicitly attested by one of the most resonant of historical documents: an exchange between Titian and the imperial ambassador Francisco de Vargas, as recorded by Antonio Pérez, secretary of state to Philip II. Pérez recounts a visit made by Vargas to the painter's studio, probably in the early 1550s, during which the ambassador asked why Titian painted with such broad strokes of the brush, almost at random, rather than with the more refined touch of the other great masters of his time. With initial modesty, the painter responded by doubting his ability to achieve the delicacy and beauty of Michelangelo's brush, or that of Raphael, of Correggio, or of Parmigianino. Even if he could, however, he would then inevitably be compared to them or, worse,

taken to be a mere imitator. But, he finally explained, ambition spurs him on, inspiring him to seek his own path to fame, just as those other masters acquired their fame by following theirs. Titian's bold brush spoke for his uniqueness. Published in 1603, this account clearly resounded in the art literature and studio culture of seventeenth-century Spain, and certainly played an influential role in the shaping of the art and career of Velázquez. As it resonated throughout Europe, in subsequent retellings it would emerge that Titian used a brush "as big as a broom."

Vasari's observation on viewing distance has often been considered something of a literary topos; it has been traced back to Horace's comment *ut pictura poesis*, which compares viewing distance in painting with the ability of a poem to hold up to close critical scrutiny. Now, while it is true that Titian, like all painters, was quite aware of viewing distance and took it into account in the design and execution of his paintings—and his more discerning patrons were certainly aware of the issue—it is misleading, I believe, to insist on this as the unique or even primary justification for his painting in bold strokes (*di macchia*). The painter invested his identity in his brush, the stroke of which was his signature. Tintoretto made this point most clamorously at the outset of his career, announcing himself by the brashness of his brush—and earning the disapprobation of critics like Vasari, who accused him of passing off unfinished canvases as completed works of art, making a mockery of the art of painting. Paolo Veronese, the graceful energies of whose brushwork defined his style, actually sent his son Carletto to study with Jacopo Bassano, whose vigorous application (*modo di colpire*) he admired.

The appreciation of the brush stroke, by painters and by those connoisseurs who truly understood their art, reminds us that such critical response is no mere projection back from our own century. Such response is especially relevant in the case of Rembrandt. In 1639 the painter sent Huygens the gift of a canvas, counseling him to hang it "in a strong light and in such a manner that it can be viewed from a distance. It will then show its brilliance best." The painting, probably *The Blinding of Samson* of 1636 (Frankfurt, Städelsches Kunstinstitut [BR. 501]), is hardly one in the later rough manner—and its gruesome subject, aggressive figural bulk, and bold chiaroscuro, as well as its sheer size, obviously demand-

ed distance. Rembrandt's postscript should not be too readily associated with the anecdote published in the early eighteenth century by Arnold Houbraken, who had studied with a Rembrandt pupil: When visitors to his studio peered too closely at his pictures, Rembrandt would pull them away, explaining that they wouldn't be able to stand the smell of the paint. It is an anecdote worthy of ancient Pliny; rather than an aesthetic injunction regarding proper viewing, it is a declaration of professional independence.

With all that paint, Rembrandt's later paintings do of course smell of the studio. But the appeal was more than olefactory; more synaesthetic, it involved the senses of touch and of sight. It was not the odor of paint that invited such close inspection but rather the materiality itself of the painted surface, the rough textures of thick impasto modified by superimposed tints. Rembrandt built his painting up from a darker ground, often no more than the prepared canvas allowed to remain visible; from that base he worked forward, toward the thickening of lead white impasto. The relative brightness of face or hands or costume detail advances forward as material substance, toward the viewer, offering itself as a complex field of sensations.

The critical response to Rembrandt's late painting, as recalled by Houbraken, seems inevitably to recall Vasari's comments on Titian's late style. When Rembrandt's paintings are seen close up, "it looked as though the paint had been smeared on with a bricklayer's trowel." Thickly brushed, smeared with both palette knife and finger, the fatty substance of Rembrandt's paint asserted its own physicality, its own material reality. (Indeed, it was said of a Rembrandt portrait that the paint was so thick that one might lift the canvas by its nose.) And yet, as those rough textures of pigment became surrogates for represented matter, they in turn were subtly reminded of their mimetic function. More or less translucent layers of color over that thickly textured foundation brought the assertive impasto back into a larger harmonic structure of pictorial illusion. Rembrandt's light worked its magic.

For all the velocity recorded in his most impetuous strokes of the brush, Rembrandt worked slowly and deliberately. The sheer quantity of paint applied and the number of layers, which required time for drying, assured that patrons would have to wait, patiently or not, before

having their portraits hanging on their walls. And, as with Titian, the very complexity of his technique virtually assured it could not be easily learned by pupils, who could only hope to imitate its superficial effect.

The anecdotal information we have about Rembrandt's working methods is indeed similar to what was recorded of Titian's. The most famous account, published by Marco Boschini in 1674, claimed to record the testimony of a painter who had worked in Titian's studio, Jacopo Palma il Giovane. According to this report, Titian

> blocked in his pictures with a mass of colors, which served as a bed or foundation for what he wished to express, and upon which he would then build. I myself have seen such underpainting, vigorously applied with a loaded brush, of pure red ochre, which would then serve as the middle ground; then with a stroke of white lead, with the same brush then dipped in red, black, or yellow, he created the light and dark areas of the relief effect. And in this way with four strokes of the brush he was able to suggest a magnificent figure. . . . After having thus established this crucial foundation, he turned the pictures to the wall and left them there, without looking at them, sometimes for several months. When he later returned to them, he scrutinized them as though they were his mortal enemies, in order to discover any faults; and if he did find anything that did not accord with his intentions, like a surgeon treating a patient he would remove some swelling or excess flesh, set an arm if the bone were out of joint, or adjust a foot if it were misshapen, without the slightest pity for the victim. By thus operating on and re-forming these figures, he brought them to the highest degree of perfection. . . and then, while that picture was drying, he turned to another. And he gradually covered with living flesh those bare bones, going over them repeatedly until all they lacked was breath itself. . . . For the final touches he would blend the transitions from highlights to halftones with his fingers, blending one tint with another, or with a smear of his finger he would apply

a dark accent in some corner to strengthen it, or with a dab of red, like a drop of blood, he would enliven some surface—in this way bringing his animated figures to completion. . . . In the final stages he painted more with his fingers than with the brush.

Molding carnal effigies out of oily pigment, Titian extended the direct tactile experience of his painting by even abandoning the mediating implement, the brush, to work directly with his hands. "Wishing to imitate the operation of the Supreme Creator," Boschini's account concludes, Titian "used to observe that he too, in forming this human body, created it out of earth with his hands." Boschini's imaginative language, evoking the operating table or anatomical theater, quite effectively captures that visceral quality of this kind of painting, the sense in which paint seems to transcend its metaphoric or correlative relation to flesh and appears instead a convincing physical substitute for it.

Whatever the reliability of his source, Boschini's report seems fully validated by the most visceral of all Titian's late paintings, *The Flaying of Marsyas* (fig. 12). Although its state of finish has sometimes been questioned, the canvas is actually signed on the rock in the right foreground: TITIANVS P. *Pinxit* or *pingebat*? The imperfect tense might seem more appropriate for a painting that so openly displays the processes of its becoming, the traces of its manufacture. The brushwork that vibrates throughout this painting finds its focus in the torso of the hanging satyr: there it is that paint becomes most programmatically incarnate. But Titian's brush has animated the entire surface in an impressive range of application; the vitality of his stroke is as various as its mimetic function. At one extreme there is the tiny brush that so delicately edges the leaves of Apollo's laurel and facets the jewels in the crown of melancholic King Midas, the foolish judge of the musical competition between a god and a mortal challenger. At the other there is the brush, "as big as a broom," that creates the close, somber atmosphere of the scene, where arboreal form and background sky knit into continuous pictorial fabric.

Unifying these two extremes of brushwork is the logic of pictorial construction. The detailed finish of objects like the two crowns, or the taut strings on the viola da braccio, serves to release the mimetic potential of the surrounding painterly energies. However, we can hardly imagine that other parts of the painting are awaiting such refined development. The strokes of white impasto that silhouette the twisted haunch of Marsyas or the trophy of his panpipes are themselves finishing touches, final accents added to articulate form. They do not represent a preliminary state, sketched in (*abbozzato*), a "bed" (as Boschini wrote) intended to serve as foundation for further elaboration; they are not the beginning but rather the end of the painting process.

Titian's *Flaying of Marsyas* is at once the visual narration of a tragic tale and a demonstration of the metamorphic art of painting. The emergent quality of its surface is central to its fullest meaning, the transubstantiation of paint. Even beyond its subject matter this dark *poesia* by the old Venetian master is cast in a profoundly Ovidian mode, as affective fiction poignantly created though self-conscious artifice. In Titian's painting, as in Ovid's poetry, tragic pathos is conveyed by the art itself. The overall unity of the composition depends upon that web of brush strokes, of *macchie*, which, mixing with the texture of the canvas, emerge from a deep tonal ground. It is just that emergence of paint that gives body, literally, to the subject. The detailed particularity of Apollo's laurel and of Midas' crown jewels functions as a guide to perception, suggesting the mimetic direction and goal of the viewing imagination, the reality we are invited to project into this roughly marked surface. Through the art we confront nature; through that fabric of markings we confront the body of Marsyas. The reality of the satyr's body depends upon the strokes and touches that construct its anatomy, each trace of the brush or smear of the finger assuming a correlative rapport with the idea of body. Seeing in and through the picture plane, beyond the material reality of paint, we participate in the fiction of the image. Our eyes and imagination follow our tactile experience. But it is just that experience, that sense of touch, that puts us in more direct contact with the painter himself.

Titian conceived the flaying of Marsyas as an image of martyrdom. The body of the satyr, suspended like some pagan St. Peter, is presented frontally and centered; even as it twists from its trussed goat legs, the torso of Marsyas is displayed nearly *in maestà*, an iconic corpus. The blood, which has so offended the sensibili-

Fig. 12. Titian. *The Flaying of Marsyas*, ca. 1570-75. Oil on canvas, 83⅞ x 81⅝ in. Kroměříž (Czech Republic), Státná Zámek

ties of some scholars, will be collected by the approaching brother satyr with a pail—a sylvan pagan equivalent to the angel with a chalice in scenes of the Crucifixion. Corporeality is crucial to Titian's image. The subject is about the sacrificed flesh of the victim, here punished for challenging the god of music. And it is the body of the victim that most surely confirms Boschini's account of Titian at work. Here we sense that blending of brush strokes with the finger; broad touches of impasto throb as revealed muscle beneath the flesh that is being so artfully removed by the vengeful god of light. Apollo applies his blade with surgical precision, and his very skill seems a deconstructive equivalent to the constructive act of the painter who created this flesh out of paint, with his own hands.

The Flaying of Marsyas was in fact in Amsterdam, inventoried in 1655 in the collection of the Countess of Arundel, following her death the previous year. While Rembrandt might very well have known the picture, such knowledge alone would hardly account for the affinities we feel between the substantial style of Titian's painting and the Dutch master's late manner. However Rembrandt may have looked to Titian—as he looked to his nearer contemporary Rubens—as a model of professional status, his closer bond was more fundamentally technical. Boschini's account of the old Titian at work parallels contemporary accounts of Rembrandt's procedure, his deliberate building up of a canvas, slowly, layer upon layer, and his use of his fingers as well as the brush. Indeed, no other of Titian's great distant disciples, not even Rubens, so closely approximates the old Venetian's feeling for paint. Only Rembrandt seems to share that material equation of oil paint and flesh; only Rembrandt seems to share that experience of moving beyond the brush to create new carnal realities with his hands. In the later part of his career, not only was he

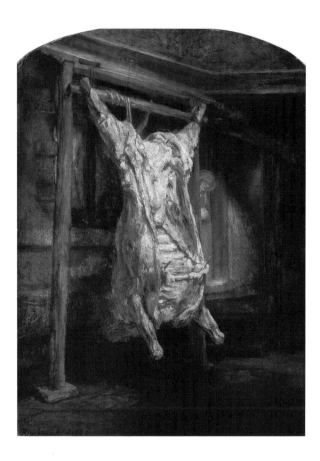

Fig. 13. Rembrandt. *The Slaughtered Ox*, 1655. Oil on wood, 37 x 26½ in. Paris, Musée du Louvre

master of a rough style in a period of more refined stylistic preferences in the Netherlands, but, as he himself proclaimed so vigorously in his late self-portraits, he was a painter not afraid to get his hands, or his clothing, dirty in the course of painting. Paint, after all, was for such masters as these the stuff of life.

Whether or not he had seen *The Flaying of Marsyas*, Rembrandt was coming to practical and expressive conclusions similar to those of his Venetian forebear. Out of his own long experience of oil painting he too had discovered in the materials of his art the secrets of life. And of death. One painting in particular might seem to suggest his direct encounter of Titian's pagan martyrdom, *The Slaughtered Ox*, signed and dated 1655 (fig. 13). The image is a reprise of a much earlier version in Glasgow (BR. 458), which features a meticulous rendering of the butchered anatomy, the organs and entrails of the flayed carcass are closely observed and transcribed. In the later rendition, however, this has been transformed into an equation of viscera and impasto. Paint itself here attests to the material reality of butchered meat. It is hard not to find in the sheer

pictorial energy invested in this carcass, in the heavy working of its rough surfaces, a creative commitment of ennobling potential. More than a large-scale still-life, this slaughtered ox becomes an heroic victim, a giant felled and trussed; its glowing flesh affirms, even as it can only recall, life. And, as the flesh is paint, its structures dependent upon the strokes of the brush, so that life is art.

From his earlier direct emulation of Titian, then, the aging Rembrandt grew closer to his Venetian model, not through continuing study of examples of Titian's art of painting but by reinventing that art for himself. Rembrandt rehearsed the discoveries that Titian made in the very nature of the oil medium. That the two eventually arrived at such similar results in the exploration of their art, which remained such a mystery to their immediate followers and more distant successors, confirms just how deeply founded was their relationship.

BIBLIOGRAPHIC NOTE

The recent literature on Rembrandt is particularly rich in both biographical and technical studies. Both, in dealing with matters of style, have devoted attention to his relationship to Titian and the Venetian tradition, a relationship that was brought to special focus in Kenneth Clark's inspiring Wrightsman Lectures, *Rembrandt and the Italian Renaissance* (New York: New York University Press, 1966). The historical and critical contexts of the relationship were more fully considered by Amy Golahny, "Rembrandt's Paintings and the Venetian Tradition" (Ph.D. dissertation, Columbia University, 1984). More recently, the topic has been addressed, with significantly different emphases, by Svetlana Alpers, *Rembrandt's Enterprise: The Studio and the Market* (Chicago: The University of Chicago Press, 1988), by Simon Schama, *Rembrandt's Eyes* (New York: Alfred A. Knopf, 1999), and by Harry Berger, Jr., *Fictions of the Pose: Rembrandt Against the Italian Renaissance* (Stanford: Stanford University Press, 2000). Julius S. Held's study of the Juno appears in his *Rembrandt Studies* (Princeton: Princeton University Press, 1991).

Exploration of the technical aspects of Rembrandt's art—in which advances in the laboratory still have left many issues unresolved—inevitably involves comparative consideration of Venetian precedent. The most sustained study in the field is now that of Ernst van de Wetering, *Rembrandt: The Painter at Work* (Amsterdam: Amsterdam University Press, 1997), who draws upon extensive experience with the Rembrandt Research Project: *A Corpus of Rembrandt Paintings*, 5 vols. to date (The Hague: Martinus Nijhoff, 1982-1986). The catalogues of a number of important exhibitions have also made significant contributions to our understanding of the painter's methods: *Art in the Making: Rembrandt* (London: National Gallery, 1988) by David Bomford, Christopher Brown, and Ashok Roy; *Rembrandt: The Master & His Workshop* (New Haven and London: Yale University Press, in association with National Gallery Publications, London, 1991), organized by Christopher Brown, Jan Kelch, and Pieter van Thiel, volume I, "Paintings"; *Rembrandt/Not Rembrandt in the Metropolitan Museum of Art* (New York, The Metropolitan Museum of Art, 1995), volume I, "Paintings: Problems and Issues," by Hubert von Sonnenburg, volume II, "Paintings, Drawings, and Prints: Art-Historical Perspectives," with contributions by Walter Liedtke et al.

Although the technical aspects of Titian's art have been less systematically explored, two important centers of investigation have been Venice and London. A review of the activities of the Soprintendenza ai Beni Artistici e Storici di Venezia is offered by the contributions of Giovanna Nepi Scirè, Paolo Spezzani, Lorenzo Lazzarini, and Giovanna Bortolaso to the exhibition catalogue *Titian, Prince of Painters* (Venice: Marsilio Editori, 1990). The investigations at the National Gallery in London, especially under the leadership of the late Joyce Plesters, have been published periodically in the Technical Reports of the gallery. Technical matters are discussed in several of the contributions to *Titian 500*, edited by Joseph Manca (*Studies in the History of Art* 45, Washington: National Gallery of Art, 1993), a symposium sponsored by the Center for Advanced Study in the Visual Arts, National Gallery of Art. The most recent publication on the subject is *Tiziano: Técnicas y restauraciones* (Madrid: Museo Nacional del Prado, 1999), a collection of conference papers, several in English, including my own "La mano di Tiziano." I have further elaborated on the critical and art historical resonance of technique and style in "Titian and the Critical Tradition," the introduction to *Titian: His World and His Legacy* (New York: Columbia University Press, 1982), and in *The Meaning of the Mark: Leonardo and Titian* (Lawrence: The Spencer Museum of Art, University of Kansas, 1988).

Of special interest with regard to the shaping role of Titian in the studio culture of the seventeenth century is the study by Gridley McKim-Smith et al., *Examining Velázquez* (New Haven and London: Yale University Press, 1988).

* BR. numbers refer to the standard catalogue by A. Bredius, *Rembrandt: The Complete Edition of the Paintings* (1935), 3rd edition, revised by H. Gerson (London: Phaidon Press, 1969).

Fig. 14. Venetian School, late 16th Century, *Portrait of Francesco Duodo*. Black chalk on blue paper. London, British Museum

A Rediscovered Late Portrait by Titian

By Frederick Ilchman

AS KENNETH CLARK NOTED in his discussion of Rembrandt's portraits, the "pictorial inventiveness of Venetian art was irresistible" to the Dutch painter.[1] Venetian portraits in general and those of Titian in particular offered both specific prototypes and general formal strategies crucial to Rembrandt's development as a portraitist. Thus the present exhibition offers an ideal context to reintroduce, after decades of obscurity, a major late portrait by Titian (see plate 6). This ambitious picture presents many affinities with Rembrandt's portraiture: the "grandiose, frontal pose" (in Clark's words); the neutral background and close-up viewpoint; the abbreviated treatment of clothing enlivened by intricate details of silk, armor, or fur; a palette of warm earth tones; and above all the human face modeled with confident impasto strokes. Yet this painting is also of great intrinsic interest, and will repay a brief consideration of its formal qualities, provenance, attribution, and the identity of the sitter.

This half-length portrait depicts an imposing, hard-featured man in armor.[2] His face is characterized by deeply set eyes, a flat forehead rising to a rounded head, a prominent bulbous nose, and a ropy mustache above a small mouth. His battle armor is typical Northern Italian of the 1550s, which gives a *terminus post quem* for the painting.[3] The crimson cloak, escutcheon in the form of a lion, and baton of command suggest a Venetian soldier of high rank.

Close examination of the picture's surface discloses that the face is in excellent condition, displaying deft highlights that add volume to the figure and encourage the viewer to range over the surface.[4] The cloak appears to have been created through an involved process layering white or pink lead, red lake, and finally vermilion. The painterly handling of the face is similarly assured, with the wrinkles not drawn on the face, but rather modeled with impasto in a nearly sculptural way. Nothing about the paint surface suggests a copyist or an inexperienced painter, nor more than one hand at work; the portrait displays conspicuous pictorial intelligence throughout.

The picture's high quality points to a private client. Venetian Renaissance painters viewed official portraits destined for public settings as routine tasks poorly compensated, and thus they typically delegated the execution to assistants. The picture also lacks an inscription or coat of arms that would suggest a public commission.

The first record of the portrait is a black chalk drawing on blue paper (fig. 14) in the British Museum.[5] The arbitrary bottom edge of the drawing indicates that it is after the picture and not preparatory to it. In 1944 this sheet was given to Palma il Giovane, and the sitter identified as Sebastiano Venier.[6] Although the timid touch of the drawing announces an artist other than Palma, the medium and handling indicate a Venetian artist at the end of the 16th century, suggesting that the painting was still in Venice at that time. The identification of Venier, however, is incorrect when compared to accepted contemporary portraits.[7] The next record of the portrait is a pen drawing made sometime between 1621 and 1627 by the young Anthony Van Dyck during his travels in Italy, in his "Italian Sketchbook" in the British Museum (fig. 15).[8] Van Dyck inscribed his drawing with the first attribution for the painting: "Titian". The sketchbook reveals the systematic effort Van Dyck made to study the art of Titian.[9]

The portrait's location before the early 20th century remains a mystery. Recent owners of the painting believed that the picture once belonged to the Trivulzio family of Milan.[10] Although much of the Trivulzio collection became the property of the city of Milan in 1927, some paintings were transferred to other private collections, for example, Titian's *Portrait of Doge Francesco Venier*.[11] The present picture may have left the Trivulzio collection then. By 1933 the painting was in the collection of Gino Bonomi of Milan when it was published, by Wilhelm Suida, as a late Titian portrait of an admiral.[12] A label on the picture's stretcher confirms the Bonomi provenance.[13] In 1931 the painting had been transferred via Florence to Bonomi's house in Monte Carlo.[14] After a sale to another private collector in Monte Carlo, it passed by descent to the consignor of

Fig. 15. Sir Anthony Van Dyck. *Sheet from "Italian Sketchbook,"* Folio 107v. Pen and ink and brown wash. London, British Museum.

the Sotheby's London Old Master Paintings Sale of 3 July 1997. The picture, sold as "Tiziano Vecellio, called Titian" (lot 63), was purchased by French & Co. of New York City.

The painting's inaccessibility in private collections explains its neglect in the literature, save for one mention in 1977.[15] Noting a similarity between the present portrait and the statue of Moses at the upper left of Titian's *Pietà* (Venice, Accademia), Fisher speculated that both the portrait and the Moses were painted by Palma il Giovane. Although both figures share leonine facial features, a cloak over the left shoulder, and to some extent the pose, modern critical opinion assigns Palma only a minor share in the *Pietà*, ascribing the Moses to Titian himself.[16] The New York portrait, in fact, has only superficial similarities with the work of Palma.

In my opinion, the attribution of the present painting to Titian, given previously by Van Dyck and Suida, is correct. The lack of a signature does not contradict this since Titian signed fewer than one quarter of his works.[17] Although the painting is freely executed, the

brushstrokes display assurance throughout. The highlights always convey information and never appear merely for painterly effect. Although the handling is tighter than some late Titian portraits, the bold impasto under the eyes can also be seen in the *Jacopo Strada* in Vienna, while the chiaroscuro and working up of the volume of the face without hard contours recalls the *Triple Portrait* in London.[18] Finally, the gleam in the eyes – a catch-light rendered by the smallest possible angular strokes – bears comparison with many Titian portraits, such as the *Triple Portrait* or the *Vendramin Family* in London, and *Philip II in Armor* in the Prado.[19] It is hard to imagine another Venetian painter who could have executed these eyes.

Given the scarcity of late Titian portraits, the best analogies reside in religious paintings, particularly those of *St. Jerome*, although these are generally less finished than his portraits. The parallels between the New York painting and the St. Jerome in the *Pietà* (fig. 16) are striking: the form and brushwork of the ears, the impas-

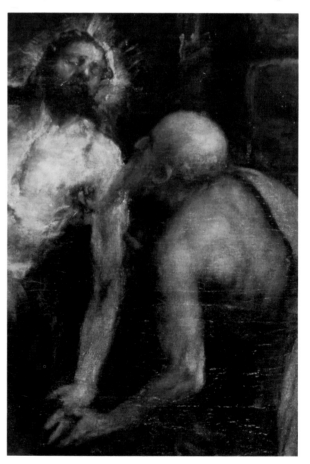

Fig. 16. Titian. *Pietà* (detail). Venice, Gallerie dell'Accademia

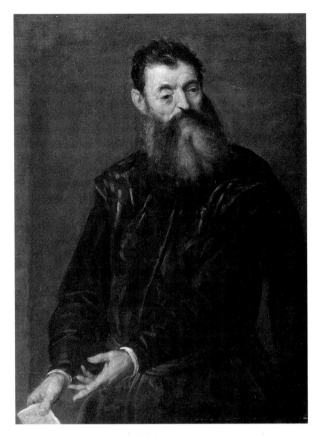

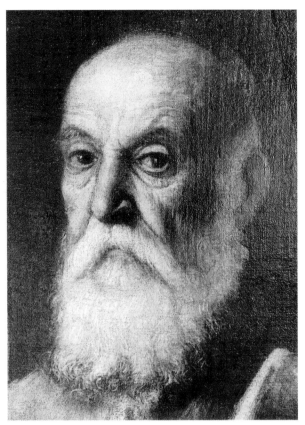

Fig. 17. Jacopo Palma, called il Giovane. *Portrait of a Man with a Letter*, ca. 1586–1590. Oil on canvas, 42½ x 32 in. Chicago, Art Institute of Chicago

Fig. 18. School of Tintoretto. *Portrait of Francesco Duodo* (detail), ca. 1587. Venice, Museo Storico Navale

to of the beard and hair, the shape of the planes and the patches of color (tan, pink, peach) that constitute the bald pate.[20] Close correspondences can also be found in the *St. Jerome* in the Brera which shares the palette of skin tones, contours of the bald skull, ears, and deeply-set eyes.[21] The technique of depicting hair and beard is identical: dry impasto strokes on top of soft, cottony wisps. The present portrait seems indeed to be by the same hand as the Brera *St. Jerome*.

By contrast, the attribution of the present picture to Palma il Giovane, posited by Fisher, is unconvincing. Palma executed remarkably few independent portraits, and his faces, such as the *Portrait of a Man with a Letter* in the Art Institute of Chicago of the 1580s (fig. 17)[22] or the *Nicolò Cappello* in the Louvre, exhibit busy sparkling highlights and impasto that seem to exist for their own sake. The brushwork focuses attention on the surface of forms rather than the forms themselves, as seen in the folds of his robes. Palma typically painted drapery, as in the *Portrait of a Collector* (*Bartolomeo della Nave?*) c. 1580

(Birmingham City Museum, U.K.), with quick, single strokes to create a zigzag pattern of hard angles.[23]

Since Titian seems to have executed the present painting from the mid-1560s to the early 1570s, a final question is the sitter's identity. He would be a Venetian middle-aged military leader of high rank in those years. As stated above, the sitter cannot be Sebastiano Venier, given the fundamental dissimilitude to known portraits of Venier. Instead, I believe that Titian's portrait depicts Francesco Duodo (1518–92), a prominent official in later 16th-century Venice and a hero at the Battle of Lepanto.[24] The evidence lies in an overlooked portrait by the school of Tintoretto in the Museo Storico Navale, Venice (fig. 18).[25] The picture shows an elderly man with the embroidered stole and robes of a Procurator, and a warship at the upper left. The picture's left edge features the Duodo coat of arms and his initials. Francesco Duodo was elected Procurator in March 1587, and this portrait likely dates from this moment. He would be sixty-nine years old here, which

seems reasonable given the white hair, prominent wrinkles, and bags under the eyes.

The New York portrait seems to depict the same man at least a decade earlier. Both men have similar prominent noses, hairlines and sideburns, ropy mustaches above small mouths, rounded eyebrows surmounting deeply set beady eyes, flat foreheads quickly becoming rounded at the crown, and similar patterns of wrinkles and smile lines around the eyes and nose. The only significant difference—the entirely white facial hair in the Museo Storico Navale portrait—results from the substantially greater age of the sitter.[26]

Duodo collected ancient sculpture,[27] began a villa near Monselice, and commissioned an altarpiece from Tintoretto for the Church of S. Maria Zobenigo, where he was buried.[28] Duodo's fame, however, can be credited to his stellar career in government and military posts from the 1560s on.[29] His innovations as *Patrono all'Arsenale* were decisive in the victory of the Christian navies over the Turkish fleet at Lepanto on 7 October 1571. Duodo, commanding the heavy galleons at the center of the Christian lines, administered the knock-out punch to the Turkish navy.

Following his return to Venice, Duodo served in high offices like the Council of Ten, and was appointed *Sopraprovveditore alla Sanità* during the Plague of 1576 (during which Titian died). In 1587 he reached the summit of prestige when elected *Procuratore*, one of the councilors from which Venetian Doges were selected.[30] In both the 1560s and early 1570s he received offices worth celebrating in a major portrait. The armor in the present picture suggests that it commemorates a military office, and may be connected with the preparations for Lepanto, or celebrations soon after the victory.

In this light, and given that the New York portrait shows a man at least a decade, and probably fifteen years younger than the sitter in the Naval Museum portrait, one can narrow the dating of the picture to the years around Lepanto, that is, c. 1571.[31] Thus, the present portrait shows a man about fifty-three years old, which corresponds to his vigorous appearance. Finally, Francesco Duodo would have been of high enough rank in Venetian society around 1571 to merit a portrait from the most famous painter of the *Serenissima*, namely Titian.[32]

This type of Venetian portrait, one which employs assured impasto in its search for form and both underscores the dignity of the sitter while simultaneously exposing his blemishes, resonated far beyond its origins in the lagoon. Indeed, this engaged approach to depicting the individual likeness proved a potent lure for countless later painters in other traditions, and continues to be cherished by collectors. One artist in particular, who never visited Venice, absorbed deeply the legacy of the great Venetian portraitists. Although Rembrandt may have seen in person only a limited number of distinguished originals, he remains perhaps the most insightful admirer of the Venetian portrait.

1. K. Clark, *Rembrandt and the Italian Renaissance*, London, 1966, p. 130.

2. Oil on canvas, 87 x 73.3 cm.

3. The lack of a protruding peascod dates the armor to the 1550s. For other examples of Northern Italian armor from the second half of the Cinquecento, see L. Boccia and E.T. Coelho, *L'Arte dell'Armatura in Italia*, Milan, 1967, plates 332–350. I would like to thank Donald LaRocca for sharing his knowledge of 16th-century armor.

4. The conservation was undertaken from September 1997 through February 1998 by Robert Sawchuck of New York City. The author is grateful for the opportunity to view the painting before, during, and after cleaning, and for the chance to discuss the picture's technique and condition.

5. Department of Prints and Drawings, British Museum, black chalk on blue paper, 297 x 233 mm, no. 5211,63.

6. H. Tietze and E. Tietze-Conrat, *The Drawings of the Venetian Painters in the 15th and 16th Centuries*, New York, 1944, p. 207, no. 989. The authors also misspelled the name of the owner as "Boboni" rather than "Bonomi." The linking of the drawing with the present painting was made by W. Suida, *Tiziano*, Rome, 1933, p. 82. The Tietzes pointed out the resemblance between the portrait and the figure of Moses from Titian's *Pietà* later restated by Fisher (see below).

7. For example, the painting by Tintoretto c. 1572 in Vienna and the even more idealized busts by Alessandro Vittoria, like the terracotta bust in the Seminario Patriarcale, Venice. These document that unlike the sitter of the present portrait, Venier had hair on the top of his head, wider-set eyes, larger ears, a more horizontal mustache, horizontal eyebrows, and a flatter forehead.

8. Department of Prints and Drawings, British Museum, no. 1957-12-14-207, folio 107*v*. Van Dyck's sketch was first connected to the present painting by G. Adriani, *Anton Van Dyck: Italienisches Skizzenbuch*, Vienna, 1940, p. 28.

9. The drawing also suggests something of the painting's provenance. The sketch after the present painting was drawn on top of—that is, later than—the other drawing on the same page, which is after Raphael's *Portrait of Leo X with Two Cardinals* (Florence, Galleria Palatina). The Raphael painting itself was

in the Uffizi in 1589, and the Pitti by 1697. (S. Ferino Pagden and M. A. Zancan, *Raffaello*, Florence, 1989, pp. 134-5.) Van Dyck thus saw the Raphael painting in Florence, a city that he visited in 1623 (C. Brown, *Van Dyck Drawings*, London, 1991, pp. 13-4). The visit to Florence occurred after his stay in Venice (August to November 1622), and therefore it seems that the present portrait was no longer in Venice by the 1620s. Van Dyck must have seen it in another city, presumably in a private collection, and copied it in 1623 or later.

10. Sotheby's, London. Letter to the present owner, October 1997.

11. H.E. Wethey, The *Paintings of Titian, II: The Portraits*, London, 1971, no. 112 (now Madrid, Fondación Colección Thyssen-Bornemisza).

12. W. Suida, *Tiziano*, p. 82, pl. CLXXb. Gino Bonomi's collection included a large altarpiece of the *Crucifixion* by Palma il Giovane which he donated to the Ambrosiana Pinacoteca, Milan, in 1933 (inv. no. 331).

13. Label on the stretcher: "Bonomi 106."

14. Customs stamps on the stretcher: "16 Ottobre 1931 / Ufficio esportazione oggetti di antichità e d'arte."

15. R. Fisher, *Titian's Assistants During the Later Years*, London and New York, 1977, pp. 103-4, fig. 93. Since Fisher misspelled the owner's name and used an old photograph presumably taken from Suida, it is apparent that Fisher never saw the original painting.

16. For example, D. Rosand, *Painting in Sixteenth-Century Venice: Titian, Veronese, Tintoretto*, Cambridge and New York, 1997, pp. 57-61, and G. Nepi Scirè in *Titian* (catalogue of the exhibition at the Palazzo Ducale), Venice, 1990, pp. 373-5.

17. C. Gilbert, "Some Findings on Early Works of Titian", *Art Bulletin* 62, no. 1 (March 1980), pp. 73-75.

18. Wethey nos. 100, 107.

19. Wethey nos. 110, 78.

20. Other Titian paintings of *St. Jerome*, such as the example in the Fondación Colección Thyssen-Bornemisza, Madrid, of about 1570-5, show a close analogy in the structure of the red cloak, as if made up of layers of gauzy cloths, and arranged in softly swinging, rather than angular, folds.

21. The ear seen in the New York portrait is identical to a type employed by Titian in portraits, as in the *Daniele Barbaro* in the Prado (Wethey no. 12), as well as religious paintings.

22. S. Mason Rinaldi, *Palma il Giovane 1548–1628: Disegni e Dipinti*, Milan, 1990, cat. no. 81.

23. Mason Rinaldi, cat. 86, with a good color reproduction. The group portraits (pp. 18-9) included in Palma's history paintings of the 1580s, such as the cycles in the Ospedaletto dei Crociferi or the Sacristy of S. Giacomo dell'Orio, both in Venice, certainly display open brushwork in the manner of Titian, but not the same careful attention to detail in skin, hair, and eyes. Palma moreover composes his draperies with red lake over white, sometimes adding black, but does not use the vermilion employed in the present portrait. Finally, as seen in the portraits in the Crociferi cycle, even in his early career Palma tried to simplify the forms of his drapery into large, angular volumes, resulting in an effect distinct from the complex soft cascades in the present picture.

24. For Duodo, see G. Gullino, *Dizionario Biografico degli Italiani*, XLII, Rome, 1993, pp. 30–34.

25. Oil on canvas, 107.5 x 86 cm, no. 952.

26. Further images of Duodo by Alessandro Vittoria, a terracotta bust (Venice, Museo Correr) and a marble bust largely by the workshop (Venice, Ca'd'Oro) from the late 1570s or early 1580s again share the similar shape of the cranium, rounded eyebrows, droopy mustache, sideburns and hairline, and wrinkles around the eyes with the present picture, T. Martin, *Alessandro Vittoria and the Portrait Bust in Renaissance Venice*, Oxford, 1998, nos. 4, 5. Although the nose of the figure in the bust is far smaller than that in the present painting, the discrepancy can be explained by the idealizing tendency of Vittoria's portrait sculpture. The engraving of Duodo in the Department of Prints and Drawings, British Museum, no.1871-8-12-506, seems to be close to the idealized face in the Vittoria busts but with some of the pose and armor of Tintoretto's Vienna *Sebastiano Venier*.

27. F. Sansovino, *Venetia città nobilissima*, Venice 1663, I, p. 372.

28. For the villa, see L. Puppi and L. Puppi Olivato, "Scamozziana—Progetti per la 'Via Romana' di Monselice e alcune altre novità grafiche con qualche quesito", *Antichità Viva* XIII, no. 4 (1974), pp. 54–82. For the altarpiece, painted c. 1581 by Domenico, see R. Pallucchini and P. Rossi, *Tintoretto: Le opere sacre e profane*, I, Milan, 1982, no. A 113. The S. Francesco de Paolo in the altarpiece bears some resemblance to Francesco Duodo, though again rather idealized.

29. The account of Duodo's career is taken from Gullino, as well as from the older source of E. Cicogna, *Delle iscrizioni veneziani*, Venice, 1824–1853, III, pp. 177–8.

30. For a full study on the Procurators, see D. Chambers, "Merit and Money: the Procurators of St Mark and their Commissioni, 1443–1605", *Journal of the Warburg and Courtauld Institutes*, 60, 1997, pp. 23–88.

31. Curiously, when present portrait seems to have been painted, Duodo was a member of a committee to which Titian himself pleaded to overturn a tax charge on 2 December 1573. Duodo voted with the rest to accept Titian's plea. ASV. Collegio, Risposte di Dentro, f. 5. anni 1572–4. c. 225. Published in C. Gandini, *Tiziano. Le Lettere*, Pieve, 1977, pp. 266–7.

32. Some of my findings on the portrait were first stated in a letter to the present owner in February 1998. Some conclusions immediately came to the attention of the press, which supported my attribution and identification of the sitter, for example, S. Melikian, *International Herald Tribune*, March 7, 1998, p. 8, and C. Vogel, *New York Times*, March 9, 1998, p. E3. My research was first presented to the public in the lecture "A Rediscovered Portrait from Renaissance Venice and the Late Titian" Circolo Italo-Britannico, Venice, March 9, 1998. Further discussion of this painting within the context of the portraits from Titian's final decade will be included in a forthcoming article on "Titian's Last Portraits."

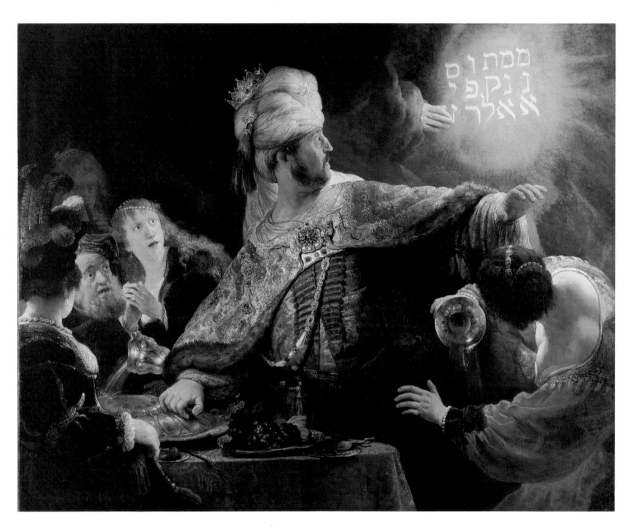

Fig. 19. Rembrandt. *Belshazzar's Feast*, ca. 1636. Oil on canvas, 66 x 82⅜ in. London, National Gallery

Rembrandt and the Venetians

By Sir Kenneth Clark

I HAVE SAID that Rembrandt's determination to master the laws of classic art was complementary to that other side of his character which, in default of a better word, I have called romantic. The finest of his early works, like the Rape of Proserpine or the Samson and Delilah, are romantic poems expressed through light and colour; and we might have supposed that in this field Rembrandt had no need of masters. But here, too, he developed his prodigious talents by the study of the Italian Renaissance, with Giorgione and Titian taking the place of Raphael and Leonardo. Venetian art had on Rembrandt an influence of a very different kind from that of Roman or Florentine. When borrowing a classic motive from a Marcantonio engraving he practically always changed the subject, and often modified the form in a way which revealed a long and enlightening process of thought. But he felt so much in sympathy with the imaginative world of Titian and Giorgione that when he took over one of their motives he usually retained the subject and even vestiges of the style. In consequence his borrowings from Venetian art are more obvious and less interesting than his borrowings from Raphael, and have long been familiar to all writers on Rembrandt.[1]

Unlike Roman and Florentine art, which he knew almost entirely from prints and drawings, Rembrandt knew Venetian art at first hand, from original pictures. It was impossible to send Raphael's frescoes to Amsterdam for sale, but it was possible to send the masterpieces of Titian; and they came in almost unbelievable quantities. A few we can identify; many are lost. The percentage of famous works of art which somehow managed to disappear between 1640 and 1840, when scientific cataloguing began, is a constant source of surprise; and in assessing Rembrandt's debt to Venetian art we must remember how incomplete and fragmentary is our knowledge of his sources. The gallery of Andrea Vendramin provides an impressive warning. This famous collection was brought to Amsterdam in the 1640's, and the sale was handled by Saskia's cousin, Gerritt van Uylenburgh. Rembrandt must have known it

well. It contained works by Bellini, Giorgione, Titian, Paris Bordone, both the Palmas, Schiavone, Tintoretto and several minor Venetians. Fortunately Vendramin had made a manuscript catalogue of his collection, with illustrations of each item,[2] which give us a fair notion of what they were like; and of the hundred and fifty-five pictures illustrated, only four can be identified today; the rest have simply vanished. If this was the wastage in a single collection, we are justified in assuming that many Venetian pictures were known to Rembrandt which are unknown to us, and we should not be debarred from claiming a Venetian origin for some of his ideas because no original exists.

In addition to the numerous Venetian pictures passing through the Amsterdam art market, many of which were no doubt copied in the atelier of Hendrick van Uylenburgh and were thus available for study even after they had been sold, Rembrandt owned what is described in the inventory as a "very large book," with nearly all the works of Titian.[3] These were, presumably, engravings after Titian's paintings, especially the series engraved by Cornelius Cort, published in the sixteenth century. But Cort's engravings alone would not fill a "very large" book, and probably it contained a number of woodcuts by Boldrini and others; also, as we shall see, drawings by Titian and his school.

There are Venetian echoes in works of the 1630's and not surprisingly the painters whose influence is most often identifiable are members of the Bassano family. The very earliest of Rembrandt's quotations from Italian art is to be found in a small panel in the Pushkin Museum, the expulsion of the Money Changers, signed and dated 1626, which, although doubted by the museum authorities, is clearly authentic.[4] The leading money changer leaves us in no doubt that Rembrandt knew one of Jacopo Bassano's numerous versions of the subject.[5] He is the figure traditionally identified as a likeness of Titian, who also appears in the version of the subject in the National Gallery, London; but in the Rembrandt he is wearing Titian's characteristic black fur-lined cloak. As the figure is in reverse he is

Fig. 20. Veronese. *Rape of Europa* (detail). Venice, Palazzo Ducale, Anti-Collegio

Fig. 21. Titian. *The Andrians (Bacchanal)* (detail) 1523–25. Madrid, Museo del Prado

probably taken from an engraving. When, nine years later, Rembrandt returned to the subject in an etching, the example of Bassano was still in his mind. The figure of Christ is taken from Durer's Small Passion (B. 23), but the diagonal composition and the stampeding animals are still openly Bassanesque, and Rembrandt has even (most exceptionally) left one of the figures in Venetian costume. No doubt it was this bustle and animation which first attracted him in Bassano, but he was also impressed by the Bassani's mastery of night pieces, with effects of candle-light and fire. The inventory of Rembrandt's collection records *een brandent leger van den oude Bassan*, where *leger* presumably means a pen or enclosure of animals; and an echo of this scene, with the terrified cattle struggling to escape from the flames, is to be found in what was once the most famous of Rembrandt's early etchings, the Angel appearing to the Shepherds (1634), where the heavenly apparition has produced a similar panic: a good example of Rembrandt using the evidence of a natural occurrence to illustrate a supernatural event.[6]

The two tricks which Rembrandt could learn from the Bassani, crowds in movement and artificial light, were soon mastered, and decisively surpassed; and already in the 1630's he had begun to absorb the far more potent influence of Titian. It is apparent in two large

paintings of the period, both clearly done- for his own satisfaction (one of them, perhaps, never sold[7]), the Belshazzar's Feast in the National Gallery (fig. 19) and the Danae in the Hermitage. The date in the Belshazzar has been erased, but the picture must be considerably earlier than Dr. Tulp's Anatomy Lesson (1632) and, although superbly effective, has faults which Rembrandt soon learned to avoid. The diagonal of Belshazzar's right arm cuts too sharply across the design; the centre, with its pool of darkness under Belshazzar's cloak, is empty; above all, there is an inconsistency of style between the group on the left, brilliantly observed, and the Italianate figure of a reveller on the right, who, in this setting, is too obviously a creation of art. She is clearly inspired by Venetian painting, and may have been taken direct from the woman helping Europa to keep her seat on the bull in Paul Veronese's picture in the Ducal Palace (fig. 20), known through a drawing or copy. No doubt Rembrandt was impressed by this piece of foreshortening, executed with such easy skill; but the wine jar in the reveller's hand shows that he was also aware of an earlier Venetian foreshortening, the woman of Andros on the ground in Titian's Bacchanal (fig. 21), presumably known from an engraving, for the figure is reversed; and it was this secondary association with drunken revelry which made him use a similar pose in the Belshazzar.

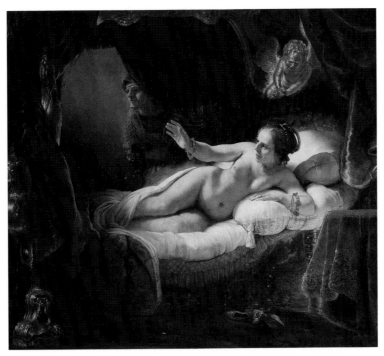

Fig. 22. Rembrandt, *Danae*, 1636. Oil on canvas, 72¾ x 80 in. St. Petersburg, Hermitage

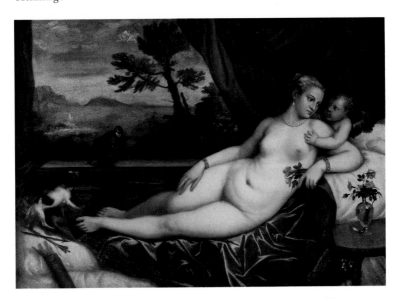

Fig. 23. Titian. *Venus and Cupid*, ca. 1550. Oil on canvas, 54¾ x 76¾ in. Florence, Galleria degli Uffizi

For once the woman is not completely absorbed into the world of Rembrandt's imagination, and is even painted with an academic anxiety unusual in his work after 1630. The Danae (fig. 22), on the other hand, is one of the most beautiful and harmonious of all Rembrandt's early pictures. Once more his point of departure was a synthesis of two Titian figures, a Venus simi-

lar to that in the Uffizi (fig. 23) and a Danae like those in Naples and the Prado. Both pictures were much copied in the sixteenth century, and Rembrandt could easily have known studio replicas. The left arm, with its bracelets, resting on a pillow, appears in both of them, and Rembrandt has repeated it, with minor changes. But how far he has departed from his originals both in

sentiment and form! The head of Titian's Venus is without expression; and her body is inert and self-contained, a kind of monstrous fruit, incapable of movement or sensation. The Danae is warm, responsive, open, outward turning. Her gaze and the gesture of her hand, at once welcoming, defensive and surprised, have the complexity of a real human response, and her body is equally far from the vegetable inertia of Titian's Venus. It is more sensuously compelling, partly because it is more natural, and partly because the light, which she greets as her lover, passes over her body like a caressing hand.

Books on Rembrandt usually describe the Danae as a likeness of Saskia, although it seems improbable that the daughter of the Burgomaster of Leeuwarden would have allowed herself to be portrayed in these circumstances, and comparison with the numerous, undoubted portraits of Saskia is by no means convincing. I suppose we can reasonably assume that the tender sensuality of the Danae was a result of Rembrandt's first happy years of marriage; but a naive concordance between the known facts of his life, almost as unrevealing as those of Shakespeare, and the abundant, but debatable, evidence of his works is often misleading. For eight years after painting the Danae Rembrandt did not return to this vein of intimate tenderness,[8] and paradoxically enough it was only after the death of Saskia in 1644 that this particular sentiment once more colours his work. There follow those two poems of domestic happiness, the Holy Families at Leningrad and Cassel. A new emotional tranquillity seems to have opened his mind to all that is fruitful and harmonious in nature and he began to enjoy the charm of the Amsterdam countryside. Most of the landscape drawings are direct notations made on the spot, from which we can follow his daily walks. But in the etchings, where he gathers these impressions together, Rembrandt makes use of those devices of lighting and grouping by which the sixteenth-century Venetians had first brought the irregularities of nature into a single focus. The etching of a landscape with a tower and barn, by the gentle undulation of the ground, the line of the roofs, the very way the light falls on the wall and thatch of the barn, achieves that kind of poetry which we call Giorgionesque; and like other similarities in Rembrandt's work this is not the result of accident, but of study.

Rembrandt undoubtedly owned a number of those prints and drawings of landscape which were done in sixteenth-century Venice under the influence of Titian. There were woodcuts, like those of Ugo da Carpi and Boldrini, with their rocky escarpments and thick, fleshy tree trunks; and there were drawings of the kind now ascribed to Domenico Campagnola, which skilfully led the eye back from the figures in the foreground, over an artfully modelled middle distance, to a background of farm buildings or a castle on a hill. How resolutely he made this style his own is shown by a curious example, a Venetian landscape drawing in Budapest[9] which certainly belonged to Rembrandt as he has gone over it with the same bold strokes that he used to correct his pupils' drawings. Only a short step in the direction of naturalism separates it from a characteristic Rembrandt landscape, such as that in fig. 24; and in comparing these two we begin to understand why Rembrandt, with his unequalled gifts of direct notation, yet felt the need to master a way of rendering landscape by which the terrain was modelled more firmly and the eye was concentrated on a single unit of trees and buildings. This lesson he then applied to his own observations, giving them a more poetic and, so to say, ideal character, but very seldom betraying by an obvious reference how much the Venetian *poesie* had influenced his style.[10] There was, moreover, a certain mood which the Venetians had made so much their own that no painter with Rembrandt's sympathetic imagination could have failed to be influenced by their vision: I mean the mood of sentimental involvement with the time of day, the quality of light, the colour of the sky, all those aspects of nature which seem to reflect our thoughts and symbolise our emotions. This achievement of art, which Ruskin called the pathetic fallacy, was almost the discovery of Giorgione,[11] and from his time onwards was associated with certain episodes in the Bible where a phrase, or sometimes only a couple of words, suggests that nature is participating in a divine revelation. Christ and the Samaritan woman by the well, the walk to Emmaus, *Noli* me *Tangere:* these are subjects in which landscape is no longer merely a background, but a protagonist; and Rembrandt, in treating these themes, did not disguise his indebtedness to the Venetian discovery. He owned a large picture of Christ and the Woman of Samaria which he attributed to Giorgione, and he

Fig. 24. Rembrandt, *Farm with a Watermill*, ca. 1650–1. Pen and ink and wash, 6¼ x 9½ in.
Groningen, Groninger Museum

probably knew at least one other Giorgionesque version of the subject, an engraving by Giulio Campagnola. This design is usually attributed to Sebastiano del Piombo,[12] but it is completely Giorgionesque in spirit, and the figures are so similar to those in the Glasgow Christ and the Adulteress—which seems, on balance, to be a Giorgione finished by Titian—that it may even be derived from a companion picture. There are at least ten representations of Christ and the Adulteress in Rembrandt's work, four paintings, four drawings and two etchings, and they show a great diversity of treatment. But all, except the early etching, are entirely Venetian in spirit, and some of them, like the etching of 1658, with its rich Paris Bordone landscape, suggest some unidentified Venetian original.

One thing they all have in common is the prominence of the well. From the beautiful drawing in the Barber Institute, Birmingham, to the late etching, it dominates the foreground and seems to be the real subject of conversation between the Samaritan woman and Our Lord. Rembrandt, who was much better versed in Christian symbolism than used to be supposed, knew that the well was a symbol of purification and virginity;

and we feel that he had also recognised its compositional value, and used it as a *repoussoir*, a firm, cylindrical block round which the surrounding greenery could freely expand. He may also have shared the Venetian feeling for the cool invisible depths of the well and melodious trickle of water, which Pater perceptively recognised as the *continuo* of Giorgionesque poetry.

In addition to these lyrical episodes in the Bible, which gave the Venetians the opportunity for mood-landscapes, there was one traditional subject which allowed them to represent nature unconstrained, the saint in the wilderness. The Venetian conception of this scene followed a curious precedent which dates back to Giovanni Bellini. Instead of a real desert, Bellini had placed his saints in the earthly paradise of the Veneto, and Titian had surrounded them by nature in her most fruitful and generative mood. Whether consciously or unconsciously, it was this contrast between the health and organic harmony of great trees and the spiritual struggle of renunciation which led him to return so often to the subject. Saints in the wilderness are the subject of two of Rembrandt's finest etchings, the St. Jerome of 1653 and the St. Francis of 1657. Once more

Fig. 25. Rembrandt, *St. Jerome Reading in a Landscape*, ca. 1652. Pen and wash, 9¾ x 8⅛ in. Hamburg, Kunsthalle. Copyright Elke Walford, Hamburg

he goes back, in imagery if not in design, to Giorgione; for Michiel, the earliest and most reliable authority on Venetian painting, records the existence of two paintings by Giorgione of St. Jerome seated in a landscape, one of them in moonlight.[13] Of these no trace remains; but at least four of Titian's renderings of the subject can be identified, two pictures in the Louvre and Milan, which were probably unknown to Rembrandt,[14] and two engravings, which he undoubtedly knew. One of these is by Cornelius Cort and, like Rembrandt's etching, it shows St. Jerome seated contemplating the scriptures. Titian had imagined him as a hero-saint in Michelangelesque pose, and this Rembrandt has rejected, thinking instead of a quiet scholar, as Giovanni Bellini might have pictured him, in cardinal's hat and cassock; but he has retained the watchful lion and the escarpment of high rocks, with a tree growing out of it. He must also have known a drawing connected with Cort's engraving (although with pagan figures), of which there is a replica in the Ecole des Beaux-Arts, Paris, and has taken from it the composition and the rustic building on the hill.

The other Titian of St. Jerome which is known to us from an engraving shows the saint kneeling in front of a tree to which he has tied his crucifix. Rembrandt has used the same motive in his etching of 1657, but has changed the St. Jerome into a St. Francis, and has made the whole scene far more dramatic. The tree which thrusts itself between the saint and his crucifix is apparently drawn from nature; and the saint himself is a counter-reformation figure, closer to Baroccio than to Titian; but the contrast of natural and spiritual energy goes back to the great Venetians.

In the preparatory drawing for his etching of St. Jerome (fig. 25) Rembrandt comes nearer to the Venetian style than anywhere else in his work. Not only is there a similarity of mood and design, but the actual technique is suggestive of Titian, although we must admit that no similar drawing by Titian has come down to us. It is true that great colourists, using line to suggest colour, nearly all arrive at a similar pen technique, with broken line and free, light-promoting contours. Giovanni Bellini's drawings are sometimes surprisingly Rembrandtesque. But the technical similarities between Rembrandt's and Titian's drawings go further than this. A famous Titian drawing in the Uffizi of an old man seated is so like a Rembrandt in the actual handwriting, that it has even been claimed as Rembrandt's work. And it is precisely in certain Venetian subjects that we are most conscious of Rembrandt using Titianesque technique. An interesting example is a late drawing in Dresden of Diana and Acteon (fig. 26). It has been frequently observed that this composition is related to an etching by Pietro Testa, but neither the style nor the design bear any relationship to Testa's playful etching; they are, on the other hand, extremely close to Titian, or one of his pupils such as Schiavone, and it seems possible that both the Testa and the Rembrandt drawing go back to a lost design by Titian.

Rembrandt's debt to the Venetians was not limited to landscape. As a portrait painter he learnt professional wisdom from the first masters of the life-size portrait; and in his later work he was inspired by Giorgionesque discoveries to paint figures which have no ostensible subject, but touch the imagination by a mysterious play of colour and light. Like all successful portrait painters, he was always on the look-out for fresh poses. In the 1630's he tried most of the current formulae: the hand

Fig. 26. Rembrandt, *Diana and Acteon*, ca. 1662-5. Pen and ink and wash, 9¾ x 13¾ in. Dresden, Kupferstich-Kabinett der Staatliche Kunstsammlungen

on the breast of Van Dyck (although with a very different effect), the communicative gesture of Frans Hals, the diagonal pose of Rubens, as well as some admirable inventions of his own; but on the whole there is very little in his early portraiture that recalls Titian. But towards the end of the decade there appeared in the Amsterdam art market Titian's so-called portrait of Ariosto (see Rosand, fig. 5). This is one of the most perfect early solutions of lifesize portraiture, and we can imagine how its balance and completeness appealed to Rembrandt at a time when he was already beginning to look for a greater equilibrium. It so happened that in the same year another masterpiece of early sixteenth-century portrait painting was offered for sale in Amsterdam, Raphael's Baldassare Castiglione (see Rosand, fig. 3). To include the Castiglione in this chapter is not so paradoxical as it seems, because in it Raphael has consciously adopted the Venetian style. Giorgione was one of Castiglione's favourite artists, and the talents of his successor, the still youthful Titian, had been praised

in Roman society by that arbiter of taste, Pietro Bembo. Several of his works had reached Rome, and had so much impressed the all-absorbing Raphael that he had re-painted the Swiss Guards in the Mass of Bolsena in a colouristic manner. In the portrait of his friend, Castiglione, he used the canvas support, the pose and the subtle colour of the Venetians in a calculated and entirely successful attempt to equal his northern rival.[14] So these two great masterpieces of the early Venetian portrait style were both in Amsterdam in 1639; in fact, they were in the same collection, that of a Spaniard named Alfonso Lopez; and Rembrandt made good use of them. On April 9th he went to the auction where the Castiglione was sold, and made a sketch of it (see Rosand, fig. 2), on which he noted that it fetched 3,500 guilders. He then attempted to combine the pose of the Raphael with that of the Titian, retaining from the Venetian picture the parapet, the position of the arm and the splendid shining sleeve; but taking from the Raphael the turn of the head and the black beret. The

result was the etching of himself (see Rosand, fig. 1) done in the same year, 1639, which is the classic image of Rembrandt in prosperity. It is remarkable that he has made the Titian the basis of a self-portrait, because the pose of the so-called Ariosto has suggested to a recent scholar[16] that this is itself a self-portrait of Titian, and this feeling may have communicated itself to Rembrandt. It is also revealing to see how strongly the rakish angle of the cap was established in Rembrandt's inner eye, so that he even imposes it on his copy of the Castiglione, thereby changing its static presence into something far less severe. The etching did not exhaust his interest in Raphael's masterpiece, and in the following year he painted the famous self-portrait in the National Gallery, London (see Rosand, fig. 6), in which Titian's quilted sleeve is replaced by the curving outline of a cloak, and our interest is concentrated on the head. The sleeve he used again in a portrait of a man in the Duke of Westminster's collection.

From this time forward Rembrandt's portraits show an increasing interest in Venetian types and poses. He continued to use the window-sill formula of early Venetian portraiture, as in a beautiful drawing at Bayonne, the most Giorgionesque of all his figure pieces. In what is perhaps a posthumous portrait of Saskia he uses the cut-off bust, with straight neckline and chain, which may have been an invention of Bellini, although the hand on the breast seems to have been introduced by Giorgione in his portrait of Brocardo. In the 1650's he studied the mature Titian so that his noble portrait, in Washington. of a young woman with a pink is really a feminine counterpart of *L'homme au gant*. Nor was Titian the only influence; the portrait of an old man recently acquired for the London National Gallery is in a pose derived from Tintoretto. And in several of Rembrandt's greatest portraits we feel the Venetian spirit permeating the whole design although we cannot point to the individual Titian or Tintoretto on which they are based. In the superb self-portrait painted in the year of his bankruptcy (see Rosand, fig. 8)—a philosopher king indifferent to misfortune—not only is the grandiose, frontal pose derived from Titian, but the pleated shirt is a part of Venetian sixteenth-century dress, which Rembrandt has put on, partly because he felt like dressing up, and partly because it gave him a strong horizontal line.

But in spite of similarities of design, the basis of Rembrandt's portraiture was very different from that of Titian. It may seem far-fetched to speak of Catholic and Protestant portraiture, but it is a fact that Titian's strongly Catholic approach to all experience, his hearty acceptance of doctrine and hierarchy, is perceptible in his attitude toward his sitters, and even in his sense of form. He saw each sitter as a type to be enhanced till it reached its perfect state, rather as our bodies will be (the theologians tell us) on the Day of Judgement. Rembrandt, who was essentially a Protestant, saw each sitter as an individual human soul whose weaknesses and imperfections must not be disguised, because they are the raw material of grace. It was this preoccupation with the individual which led him to study his own face so relentlessly. He was himself the only sitter who could reveal all the ups and downs of confidence, the shining and obfuscation of inner light, which go to make up the individual soul; and the knowledge thus acquired enabled him to grasp and concentrate on the spiritual state of each sitter. How infinitely subtle and bafflingly complex is the character who gazes at us from the late self-portrait in the Rijksmuseum and how arrogantly external by comparison are the self-portraits of Titian. And yet, the pictorial inventiveness of Venetian art was irresistible to him, so that he derived ideas for portraits from the most unlikely sources. Two examples will show how he could relate Venetian motives to direct experience in the same way he had translated the "judicious inventions" of Raphael.

The Vendramin Collection contained several of those pictures representing ample, uncorseted ladies, who are, perhaps, not sufficiently athletic for modern taste, but who obviously appealed to Venetian amateurs in the mid-sixteenth century. One of them, on folio 51 of the manuscript catalogue, is of a type generally described as by Palma Vecchio, of which, in fact, two versions still survive.[17] Rembrandt has not been interested by the implications of the subject, but he has been delighted with the circular movement of the pose, and has seen how it could give a new character to the window-frame device, which he had already used several times. Thus, from a cloying and artificial formula he has made one of the most fresh and natural of all his portraits, the picture of Hendrickje in Berlin. It happens that twenty years earlier, the first and most famous of all

these Venetian beauties was to be seen in Amsterdam, also in the collection of Alfonso Lopez, Titian's *Flora* (see Rosand, fig. 4). Rembrandt was delighted by this version of pagan opulence and determined to equal it. But in 1633, when he painted Saskia as Flora, he had not yet understood that the sensuous appeal of the Titian lay to some extent in the extreme simplicity of the means, the large areas of white linen, the almost equal area of radiant flesh, with the hands alone providing two points of denser modelling. Rembrandt in his exuberance decided to dress up his bride in much richer materials, to give her a much larger bunch of flowers. He wanted, in every sense of the words, to lay it on thick; and faced with this amiable apparition, we are grateful for his extravagance. Eight years later he is in a more soberly domestic frame of mind, but he has not forgotten the pose of the Flora, and so he treats it exactly as he was to treat the Palma in the Vendramin Collection: he uses it as the basis of a portrait in contemporary costume, the picture of Saskia in Dresden (see Rosand, fig. 7). Finally, about 1656, he returns to the subject of Flora in the enchanting portrait of Hendrickje in

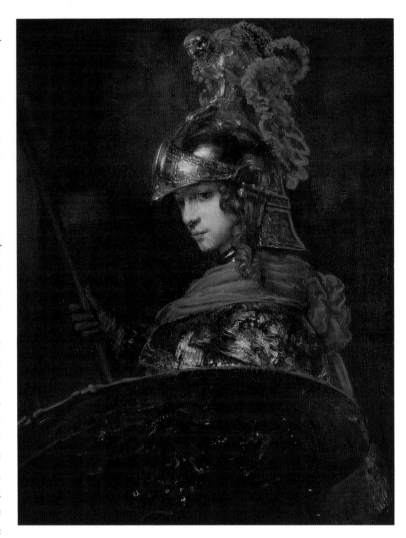

Fig. 27. Rembrandt, *Minerva*, 1661. Oil on canvas, 46½ x 35¾ in. Lisbon, Gulbenkian Foundation

the Metropolitan Museum, New York (see plate 1). By now he has learnt the value of simple planes and the areas of light and dark are similar to those of Titian. Rembrandt has understood the pictorial meaning of the Flora not merely been excited by its imagery. He has also invented his own world of forms which after 1650 became basically rectangular, built up of shallow cubes; whereas Titian's form-world is basically ovoid, and always develops a curved surface.

Beyond the greater consistency of design is a consistency of vision. The slightly ludicrous, almost touching, discrepancy between the clothes and the persons they encase, evident in the National Gallery Flora, and even more pronounced in a picture of Bellona, in the Metropolitan, was, after all, due to a failure of unifying

imagination. The trappings belong to a world of fantasy, are indeed a belated display of mannerist accomplishment. The persons belong to the world of experience— not simply visual experience, but daily human contact— and are represented without any mitigation which might bring their homely features into harmony with their splendid accoutrements. Fifteen years later than the Metropolitan Bellona, he painted the armed figure (its intention is uncertain) in the Gulbenkian Collection (fig. 27). The beautiful head is half in shadow, and so unemphatic that scholars are unable to decide whether it is a man or a woman, Mars, Minerva or Alexander the Great. By its mood it frees our minds for the contemplation of the helmet. This helmet is a marvellous child of Rembrandt's imagination, completely

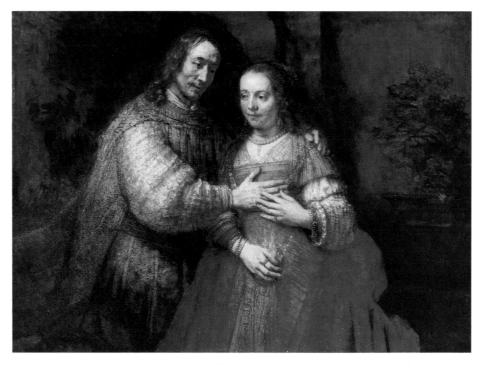

Fig. 28. Rembrandt. *The Jewish Bride*, ca. 1668. Oil on canvas, 48 x 65½ in. Amsterdam, Rijksmuseum

recreated in paint; and the rich facture is used to express emotions very different from the cheerful confidence in craftsmanship which is the chief condition of the earlier armour pieces. It is a deeply personal picture; and yet the whole idea of a handsome shadowy face, mysteriously subordinated to shining armour, was unquestionably one of the innovations of Giorgione; and in this instance Rembrandt seems to have had an actual picture in mind, feeble enough if we can judge from the copy in the Vendramin Catalogue: a figure in armour, also of indeterminate sex, there attributed to Paris Bordone.

At the beginning of this book [Clark's *Rembrandt and the Italian Renaissance*] I mentioned Livingstone Lowes' rich, discursive study of the creative process. It uncovered the layers of association which go to the making of a masterpiece; it suggested that great works of art can be (and indeed usually are) involved with memories of other works of art; and it showed how the accident—which is never quite an accident—of a subject or a commission can suddenly release these memories and concentrate them, so that they transform direct experience. I mention this study of Coleridge again because the picture which I shall now examine, the picture known as The Jewish Bride (fig. 28), has the

magic of a great poetic utterance. Of all Rembrandt's works it is the most haunting and draws upon emotions from the deepest pools of the mind. As so often, the motive of the Jewish Bride seems first to have entered Rembrandt's consciousness as one of Raphael's "judicious pictorial inventions." A drawing in the Kramarski Collection shows Isaac and Rebecca embracing, with Abimalech looking on. It is a reminiscence of a scene in Raphael's *loggie*, representing the same subject, and Rembrandt has retained the overall pose of the figures, while changing the classical garments into contemporary dress. Incidentally, the fountain in the Raphael has become a rather peculiar flowering shrub in a shallow pot—or perhaps it is still intended to be a fountain: at all events it seems to have had a symbolic importance for Rembrandt, for since the picture has been cleaned it has reappeared. The date of the drawing is uncertain. Recognising its affinity with the Jewish Bride, students have tried to put it as late as possible, but have not succeeded in dating it within ten years of the picture. Viewed purely stylistically it has all the signs of an early drawing. The long loops, the fin-like hands, the formalistic heads can all be paralleled in drawings of the 1630's.

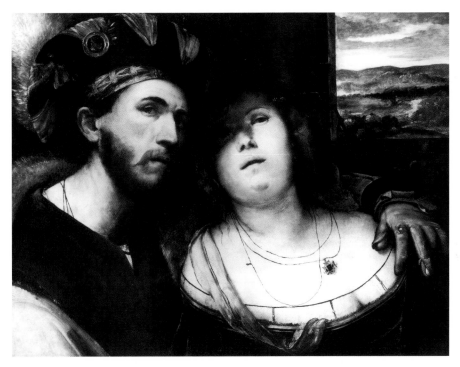

Fig. 29. Altobello Meloni, *The Lovers*. Oil on panel, 20½ x 28⅛ in. Dresden, Staätliche Kunstsammlungen

Of all Raphael's inventions (for although the execution of the Isaac and Rebecca is by Giulio Romano the invention is probably Raphael's) this is the most lyrical, and, as has often been remarked, the most Venetian;[18] as with the Castiglione, it was probably done with Titian or Giorgione in mind. The actual theme of loving encounter had a peculiar appeal to the Venetian painters, perhaps because its earliest and most memorable representation in art stood at the heart of their city, the porphyry group[19] on the corner of the Treasury of St. Mark's. The motive appears in representations of the Visitation, in meetings of Jacob and Rachel, of which there is a famous example by Palma in Dresden; and a drawing in Copenhagen of the meeting of Jacob and Laban, although personally I doubt if it is authentic, shows that the motive was known in Rembrandt's studio. Finally the theme of loving embrace provided a typical Venetian subject, which seems to have been invented by Giorgione[20] and become fashionable in the 1520's, the composition known as "The Lovers." At some time in the 1660's a Venetian treatment of this subject re-awakened Rembrandt's interest in this motive which may have lain buried in his memory for almost thirty years. Indeed it is difficult not to believe that the actual picture which inspired him was the one now in Dresden (fig. 29),[21] which, up to the time of Cavalcaselle, was universally accepted as a Giorgione. Even supposing that this picture has not been cut down (and "The Lovers" pictures in the Brera and Buckingham Palace are both three-quarter length), the relation of the figures, the turn of the man's head and the placing of his hand on the woman's shoulder are all strikingly similar. But how far removed from the Jewish Bride in its effect on our feeling is this rather prosaic image of physical attachment! The Venetian lovers seem flatly, and in the case of the lady, almost indecently material. There is little trace of the mysterious poetry by which Giorgione transformed the world of sensation. Rembrandt not only equals Giorgione in his power of spitirualising matter, but adds a new dimension of human understanding. The relationship between the figures has a depth and subtlety which no Venetian artist, except perhaps Lorenzo Lotto, could comprehend. These are two individual souls, who nonetheless embody certain universal and enduring truths: that we need each ofther, that we can achieve unity only through tenderness, and that the protection of one human being by another is a solemn responsibility.

The Jewish Bride is the climax of Rembrandt's life-long struggle to combine the particular and the universal, and he has achieved his aim in two ways; by seing the life around him as if it were part of the Old Testament, and by relating accidents of gesture to the deep-rooted, recurring motives of mediterranean art. To argue over the picture's title is frivolous. As in all the greatest poetry, the myth, the form and the incident are one. Rembrandt saw any loving couple, long-sought and wholy devoted, as Isaac and Rebecca; and whether or not the position of their hands is that of a Jewish betrothal, it is an ancient and satisfying symbol of protective union, which, in the light of Rembrandt's emotion, becomes one of the most moving areas of paint in the world.

Since de Piles, in the seventeenth century,[22] the comparison of Rembrandt and Titian has been a commonplace of criticism. I have mentioned more frequently the name of Giorgione, and it may seem farfetched to compare this shadowy figure, with his limited and uncertain output, to an artist as abundant and many-sided as Rembrandt. But the fact is that of Rembrandt's poetic themes an astonishing number seem to have been initiated by Giorgione. Christ and the woman at the well, lovers embracing, handsome youths in shining armour, saints in wooded landscapes, moonlight scenes, portraits of men and women leaning on window-sills: we know from Michiel and other irrefutable early sources that these were the subjects introduced and perfected by Giorgione: not by Titian, but by Giorgione. So I do not think it fanciful to say that in one particular mood—call it lyrical or romantic—Rembrandt had a real affinity with Giorgione. It is a measure of his range that in the last chapter we can look at him from an almost opposite point of view.

1. One example usually quoted is the etching of the Supper at Emmaus (1654) where the noble and fatherly figure of Christ, in contrast to the sacrificial figure in the picture of 1648, is clearly inspired by Titian's painting of the subject now in the Louvre, which is known to have been in Amsterdam at the time.
 Another is the etching of the Virgin with the Instruments of the Passion, which is similar to several surviving Titians of a Mater Dolorosa. This is perhaps the closest Rembrandt ever came to an actual imitation of an Italian painting, although the addition of the Instruments of the Passion is unusual in Venetian art and Rembrandt may have had in mind a Spanish picture inspired by Titian.

2. Now in the British Museum. Published by Tancred Borenius, The Picture Gallery of Andrea Vendramin, London, 1923.

3. 216 Een dito (boeck) seer groot, met meest alle wercken van Titaen.

4. Published by Vitale Block in Apollo, October 1964, p. 294.

5. The National Gallery Catalogues, Italian Sixteen Century, Venetian School, lists four versions. Another is in the Prado. If Rembrandt saw an original it could have been that in the Arundel Collection, listed in the inventory of 1651 (cf. Mary F.S. Harvey, Thomas Howard, Earl of Arundel, 1921, p. 475). But more probably he knew an engraving.

6. Even in this unclassical scene one figure, the running shepherd in the foreground, has a Hellenistic movement, and may be a memory of the angel in Raphael's Heliodorus.

7. It is often assumed that no. 347 of the inventory, Een groot Stuck Danae, refers to the Hermitage picture. But as the entry is corrected in ink to Dianae and since Rembrandt's name is not mentioned, the identification is by no means certain. A large picture described as Dane was in the collection of the widow of Edouart van Domselaer in Amsterdam.

8. The only exception is that curious exercise in the genre of Ostade, the Holy Family of 1640 in the Louvre.

9. Published by Benesch (no. 1369), who says it was recognized by Edith Hoffmann. I have not seen the original, but in reproduction the hypotheses is convincing.

10. Almost the only exception is a drawing of the Rest in the Flight belonging to the Norton Simon Foundation (Ben. 965).

11. This is no place to discuss the influence of the youthful Giorgione on the aged Bellini, but it should be noted that there are instances of the pathetic fallacy in Giovanni Bellini's work dating from before Giorgione's childhood.

12. This was first proposed by Adolfo Venturi, Storia dell'arte italiana, Vol IX, 3, p. 494, and has no documentary confirmation. The landscape in the print was probably added by Campagnola.

13. This seems to be the first recorded Venetian night piece, and the forerunner of Savoldo. How far Rembrandt's night pieces such as the beautiful Rest in the Flight in Dublin owed anything to the Venetians it is hard to say. Probably he absorbed their lessons indirectly through Elsheimer.

14. Neither of these could have been known to Rembrandt in the original, but copies of both exist, e.g. a picture reproduced in Richter's Giorgione, Chicago, 1937, pl. 74.

15. The colour and tonality of the Castiglione is almost the same as Giorgione's picture of an old woman inscribed Col Tempo, now in the Venice Academy.

16. Cecil Gould in National Gallery Catalogues, The Sixteenth Century, Venetian School, 1959.

17. One, with a landscape, in Berlin (Cat. no. 197a); another, in which the lady is playing a lute, is at Alnwick, Northumberland. Both are currently ascribed to Palma.

18. A very similar pair of embracing lovers appears in a Venetian picture in the National Gallery, London (no. 1123) traditionally ascribed to Giorgione. It could be the echo of a lost Giorgione design, but more probably it also derives from the Raphael-Giulio Romano group in the Loggia.

19. The likeness between the Jewish Bride and the porphyry Tetrarchs of St. Mark's can only be coincidental. Nevertheless it is worth noting that Rembrandt knew one of these figures, from a woodcut in a book which was certainly in his possession, the Habiti Antichi e Moderni of Cesare Vecellio, Venice, 1598.

20. Giorgione's Lovers still existed in the Borghese Collection in 1773 when it was engraved by Domenico Cunego, cf. Bernard Berenson, Venetian Painters, illustrated edition, 1957, vol. II, pl. 681.

21. No. 221, with tentative attribution to Callisto da Lodi or Romanino. Berenson lists it as Domenico Mancini but Mancini's signed altar-piece in Lendinara is dated 1511, which would seem to me at least ten years too early for the Dresden Lovers.

22. For de Piles' comparison of Rembrandt and Titian, cf. Seymour Slive, op. cit., pp. 131-2.

Plates

Rembrandt Harmensz van Rijn
(1606–1669)

1. *Flora*, ca. 1654
 Oil on canvas
 39⅜ x 36⅛ in. (100 x 91.8 cm)

The Metropolitan Museum of Art, Gift of Archer M. Huntington, in memory of his father, Collis Potter Huntington, 1926, 26.101.10

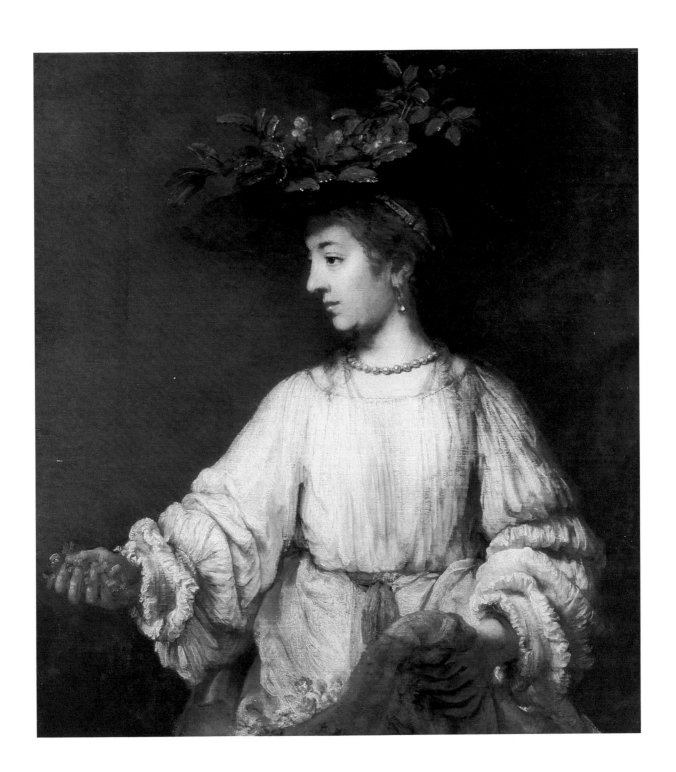

Rembrandt Harmensz van Rijn
(1606–1669)

2. *The Apostle James Major*, 1661
 Signed and dated lower right *Rembrandt f 1661*
 Oil on canvas
 35½ x 30¾ in. (90 x 78 cm)

Private Collection

Rembrandt Harmensz van Rijn
(1606–1669)

3. *Young Man in a Black Beret*, 1666
 Signed and dated lower left *Rembrandt f. 1666*
 Oil on canvas
 28⅛ x 24¾ in. (71.6 x 62.8 cm)

The Nelson-Atkins Museum of Art, Kansas City, Missouri
(Purchase: Nelson Trust) 31–75

Studio of Rembrandt Harmensz van Rijn
(1606–1669)

4. *Lamentation*, ca. 1650
 Signed and dated *Rembrandt f. 1660*
 Oil on canvas
 71 x 78 IN (180.3 x 198.7 cm)

The John and Mable Ringling Museum of Art, Bequest of
John Ringling, 1936, SN 252

Tiziano Vecellio, called Titian
(ca. 1488–1576)

5. *Portrait of a Man, so-called Friend of Titian*,
 ca. 1550
 Inscribed *Di Titiano Vecellio singolare amico*
 Oil on canvas
 35½ x 28½ in (90.2 x 72.4 cm)

Fine Arts Museums of San Francisco, M. H. De Young
Memorial Museum, Gift of the Samuel H. Kress Foundation,
D61.44.17

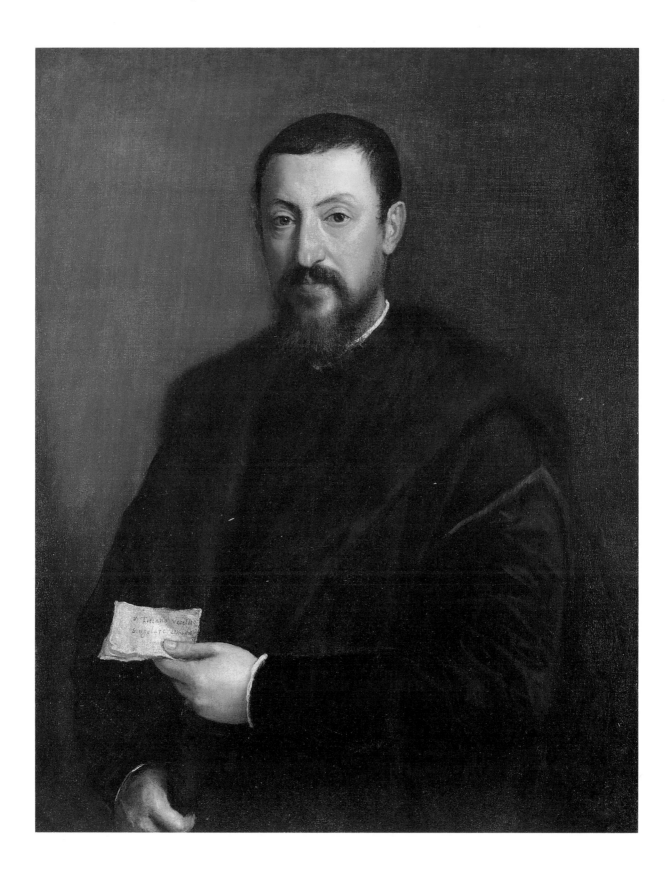

Tiziano Vecellio, called Titian
(ca. 1488–1576)

6. *Portrait of Francesco Duodo* (1518–1594)
 Oil on canvas
 33 x 28½ in. (84 x 72.4 cm)

French & Company, Inc., New York

Tiziano Vecellio, called Titian
(ca. 1488–1576)

7. *Christ Crowned with Thorns*, ca. 1560–70
 Oil on canvas
 20½ x 16 in. (52 x 40.6 cm)

Private Collection

Jacopo Robusti, called Tintoretto
(1518–1594)

8. *The Raising of Lazarus*, 1573
 Oil on canvas
 27¼ x 31⅛ in. (69.2 x 79.1 cm)

Private Collection

Jacopo Robusti, called Tintoretto
(1518–1594)

9. *Self-Portrait*, 1546–48
 Oil on canvas
 17¾ x 15 in (45 x 38 cm)

Philadelphia Museum of Art, Gift of Marion R. Ascoli and
the Marion R. and Max Ascoli Fund in honor of Lessing J.
Rosenwald 1983-190-1

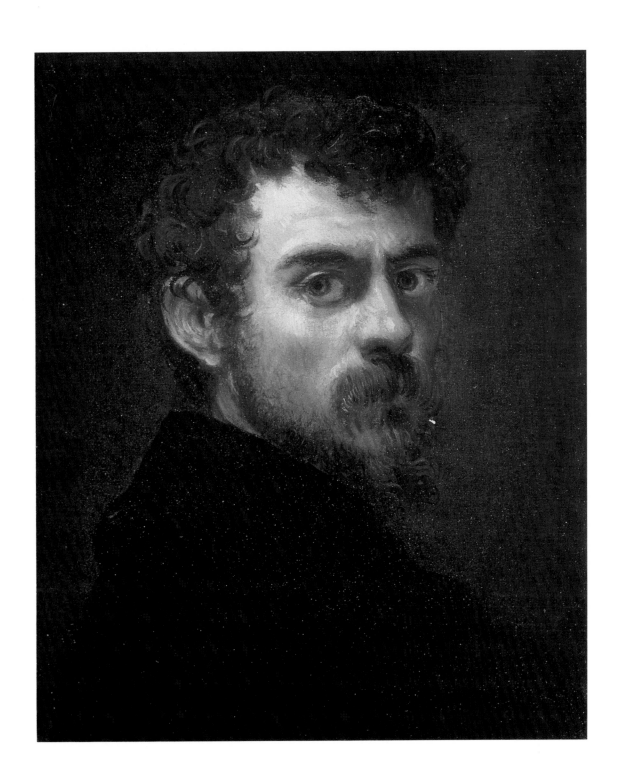

Jacopo Robusti, called Tintoretto
(1518–1594)

10. *Portrait of a Man*, 1546–48
 Oil on canvas
 23 x 17¾ in. (58.4 x 45 cm)

Private Collection

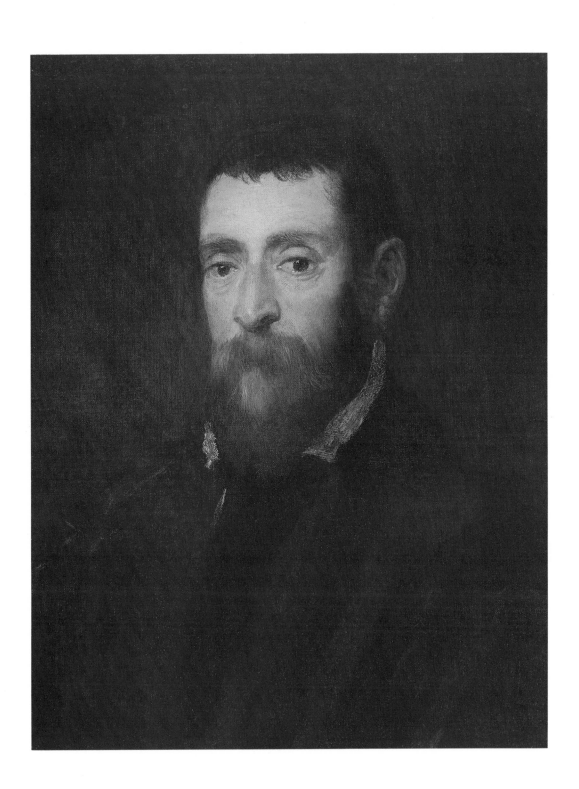

Jacopo Robusti, called Tintoretto
(1518–1594)

11. *Man of Sorrows,* ca. 1545
Oil on canvas
35 x 34½ in. (89 x 87.5 cm)

Private Collection

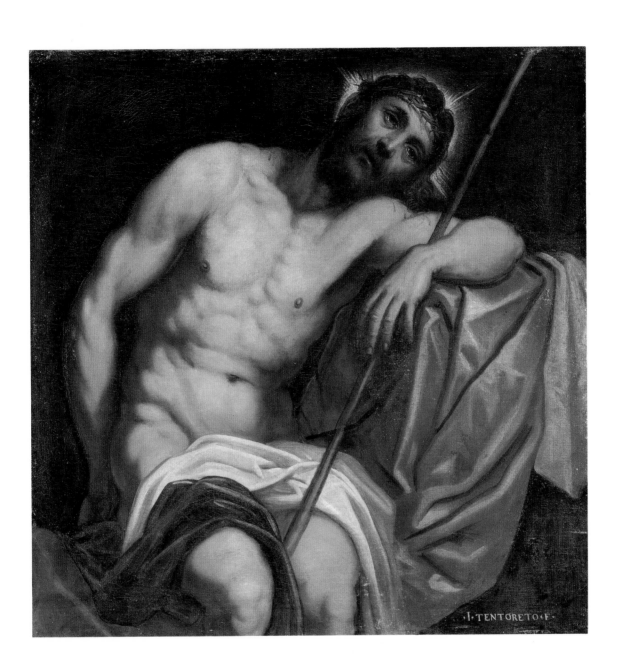

Paolo Caliari, called Veronese
(1528–1588)

12. *Christ Crowned with Thorns*, 1582–85
Oil on canvas
29¾ x 22½ in. (75.5 x 57 cm)

Piero Corsini, Inc.

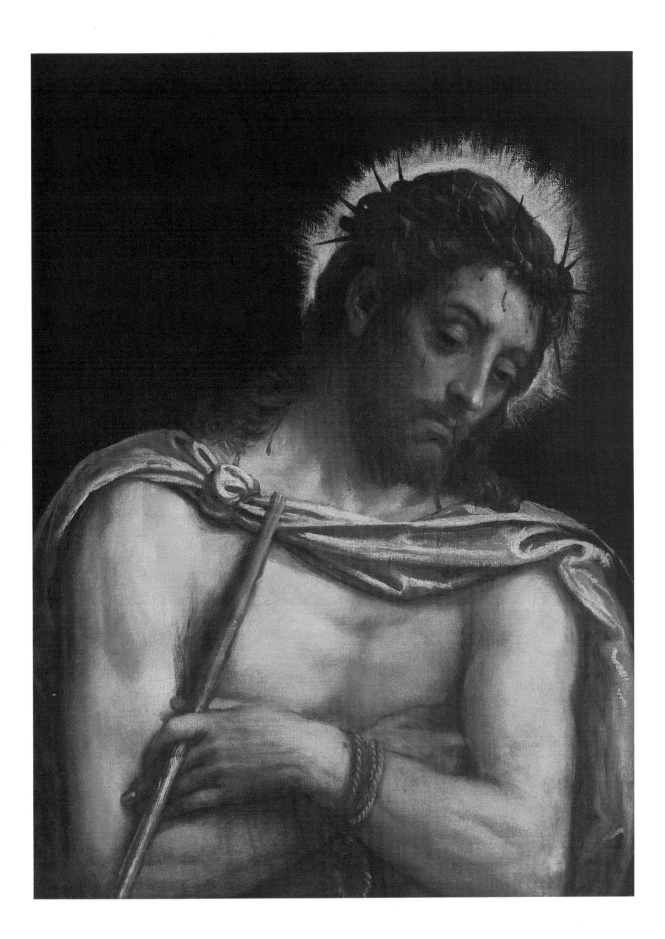

CHECKLIST TO THE EXHIBITION

Rembrandt Harmensz van Rijn
(1606–1669)

1. *Flora*, ca. 1654
Oil on canvas
39⅜ x 36⅛ in. (100 x 91.8 cm)

The Metropolitan Museum of Art, Gift of Archer M. Huntington, in memory of his father, Collis Potter Huntington, 1926, 26.101.10

PROVENANCE
Earl Spencer, Althorp House, Great Brington, Northamptonshire, by 1822

EXHIBITED
Amsterdam, Stedelijk Museum, *Rembrandt: Schilderijen bijeengebracht ter gelegenheid van de inhuldiging van Hare Majesleit Koninggen Wilhemina*, 1898, no. 106; London, Royal Academy of Arts, *Exhibition of Works by Rembrandt*, 1899, no. 95; Cambridge, Massachusetts, Fogg Museum of Art, *Rembrandt Paintings and Etchings*, 1948, no. 11; Amsterdam, Rijksmuseum, and Rotterdam, Museum Boymans, *Rembrandt tentoonstelling: Ter herdenking van de geboorte van Rembrandt op 15 Juli 1606*, 1956, no. 74

LITERATURE
J. Smith, *A Catalogue Raisonné of the Works of the Most Eminent Dutch, Flemish, and French Painters*, London, 1829–1842, vol. VII, no. 543, as *A Young Lady*, etched by A. Pond; W. von Bode, with the assistance of C. Hofstede de Groot, *The Complete Works of Rembrandt*, Paris, 1897-1906, vol. VI, pp. 10–11, no. 420, suggests Titian's influence, dates the painting about 1655–1660; C. Hofstede de Groot, *De Rembrandt tentoonstelling te Amsterdam*, Amsterdam, 1898, no. 106, as *Flora*; C. Hofstede de Groot, *A Catalogue Raisonné of the Works of the the Most Eminent Dutch Painters of the Seventeenth Century, Based on the Work of John Smith*, 1908–27, vol. VI, 1916, no. 202, as *Flora*, about 1656–58; F. Monod, "La Galerie Altman au Metropolitan Museum de New York", *Gazette des beaux-arts*, 5th series, 8 (1923), p.307; W.R. Valentiner, *Rembrandt Paintings in America*, New York, 1931, no. 122, as *Hendrickje as Flora*; A. Bredius, *Rembrandt Gemälde*, Vienna, 1935, no. 114; J. Rosenberg, *Rembrandt: Life and Work*, rev. ed. London, 1964, pp.54–55, 164–65, considers Hendrickje the model; K. Bauch, *Rembrandt: Gemälde*, Berlin, 1966, no. 282; K. Clark, *Rembrandt and the Italian Renaissance*, New York, 1966, p. 137, on Titian's influence; M.W. Ainsworth et al., *Art and Autoradiography: Insights into the Genesis of Paintings by Rembrandt, Van Dyck, and Vermeer*, New York, 1982, pp. 62–66; C. Tumpel, *Rembrandt*, Antwerp, 1986, no. 111, as *Hendrickje als Flora*; J. Kelch, *Rembrandt: The Master and his Workshop*, 1991–1992, exhibition cat-alogue, vol. I, no. 41, as *Flora*; L. J. Slatkes, *Rembrandt: Catalogo completo dei dipinti*, Florence, 1992, no. 297; Walter Liedtke et al., *Rembrandt/Not Rembrandt in the Metropolitan Museum of Art: Aspects of Connoisseurship*, vol. II, 1995, no. 12, pp. 69–70, illus. p. 71, catalogue entry by Walter Liedtke

Rembrandt Harmensz van Rijn
(1606–1669)

2. *The Apostle James Major*, 1661
Signed and dated lower right *Rembrandt f 1661*
Oil on canvas
35½ x 30¾ in. (90 x 78 cm)

Private Collection

PROVENANCE
Possibly sale of the heirs of Caspar Netscher, A Schouman et al., The Hague, July 15, 1749, lot 122, as *A Pilgrim Praying*, no dimensions (see Hofstede de Groot, 1916, no. 194c); Mackenzie of Kintore; Sir J. Charles Robinson, CB, London; Consul Edmund Friedrich Weber, Hamburg, 1872; Charles Sedelmeyer, Paris, 1895; Maurice Kann, Paris, 1901; Duveen Gallery, Paris; Reinhardt Galleries, New York, 1913; John N. Willys, Toledo, Ohio, by descent to Isabel van Wie Willys, her sale, Parke-Bernet Galleries, New York, October 25, 1945, no. 16; Billy Rose, New York, 1950; Oscar B. Cintas, New York; Mr. and Mrs. Stephen C. Clark, New York by 1955

EXHIBITED
On loan to the Metropolitan Museum of Art, New York, 1958; New Haven, Yale University Art Gallery, *Paintings, Drawings and Sculpture Collected by Yale Alumni: An Exhibition*, May 19-June 26, 1960, p. 14, no. 12, illus., loaned by Stephen C. Clark; Boston, Museum of Fine Arts, *Prized Possessions: European Paintings from Private Collections of Friends of the Museum of Fine Arts*, 1992, no. 121, pp. 198–9, catalogue entry by Peter Sutton; On loan to the Museum of Fine Arts, Boston; On loan to the Israel Museum, Jerusalem; Melbourne, National Gallery of Victoria, *Rembrandt: A Genius and his Impact*, October 1–December 7, 1997, no. 21, pp. 158–160, illus., cat. entry by Albert Blankert, also National Gallery of Australia, Canberra, December 17, 1977–February 15, 1998

LITERATURE
C. Hofstede de Groot, *A Catalogue Raisonné of the Works of the the Most Eminent Dutch Painters of the Seventeenth Century, Based on the Work of John Smith*, 1908–27, vol. VI, 1916, p. 121, no. 170 (possibly identical with no. 194c); O. Benesch, "Worldly and Religious Portraits in Rembrandt's Late Art,"

Art Quarterly, vol. XIX, no. 4, 1956, p. 346; K. Bauch, *Rembrandt: Gemälde*, Berlin, 1966, no. 236; A. Bredius, *Rembrandt: The Complete Edition of the Paintings*, 3rd edition, revised by H. Gerson, London, 1969, no. 617; G. Schwartz, *Rembrandt: Zijn leven, zijn schilderijen*, Maarssen, 1984, p. 313; C. Tumpel, *Rembrandt*, Antwerp, 1986, no. 8

Rembrandt Harmensz van Rijn
(1606–1669)

3. *Young Man in a Black Beret*, 1666
Signed and dated lower left *Rembrandt f. 1666*
Oil on canvas
28⅛ x 24¾ in. (71.6 x 62.8 cm)

The Nelson-Atkins Museum of Art, Kansas City, Missouri (Purchase: Nelson Trust) 31–75

PROVENANCE
Lord Leconfield, Petworth, 1883–1928; Duveen Brothers, 1928–31, sold to the present owner in 1931

EXHIBITED
Melbourne, National Gallery of Victoria, *Rembrandt: A Genius and his Impact*, October 1–December 7, 1997, no. 26, pp. 178–9, illus., cat. entry by Albert Blankert, also National Gallery of Australia, Canberra, December 17, 1977–February 15, 1998

LITERATURE
C. Hofstede de Groot, *A Catalogue Raisonné of the Works of the the Most Eminent Dutch Painters of the Seventeenth Century, Based on the Work of John Smith*, 1908–27, vol. VI, 1916, pp. 364–5, no. 780; K. Bauch, *Rembrandt: Gemälde*, Berlin, 1966, no. 443; A. Bredius, *Rembrandt: The Complete Edition of the Paintings*, 3rd edition, revised by H. Gerson, London, 1969, no. 322; G. Schwartz, *Rembrandt: Zijn leven, zijn schilderijen*, Maarssen, 1984, p. 339; C. Tumpel, *Rembrandt*, Antwerp, 1986, no. 224

Studio of Rembrandt Harmensz van Rijn
(1606–1669)

4. *Lamentation*, ca. 1650
Signed and dated *Rembrandt f. 1660*
Oil on canvas
71 x 78¼ in. (180.3 x 198.7 cm)

The John and Mable Ringling Museum of Art, Bequest of John Ringling, 1936, SN 252

PROVENANCE
Marquess of Abercorn, by 1836; Duke of Abercorn, Baron's

Court, Ireland, 1899; Forbes and Paterson, London; Comtesse de Bearn, Paris; Comtesse de Behague, Paris, sale, Christie's, London, May 28, 1929, no. 76, purchased by John Ringling, by whom given to the present owner in 1936

EXHIBITED
London, British Institution, 1835, no. 115; Dublin, National Gallery of Ireland, c.1880, on loan; London, Royal Academy, *Winter Exhibition*, 1876, no. 153; London, British Institution, 1899, no. 94; Detroit, Institute of Fine Art, *Paintings by Rembrandt*, 1930, no. 53; New York, World's Fair, *Masterpieces of Art*, 1940, no. 84; Raleigh, North Carolina Museum of Art, *Rembrandt and His Pupils*, November 16–December 31, 1956, no. 19; Milwaukee, Milwaukee Art Institute, *Six Great Painters*, 1957; Montreal, Museum of Fine Arts, *Rembrandt and his Pupils*, Janury 9–February 23, 1969, p. 68, no. 14, also Toronto, Art Gallery of Ontario, March 14–April 27, 1969

LITERATURE
J. Smith, *A Catalogue Raisonné of the Works of the Most Eminent Dutch, Flemish, and French Painters*, London, 1829–1842, vol. VII, no. 95; W. von Bode, with the assistance of C. Hofstede de Groot, *The Complete Works of Rembrandt*, Paris, 1897–1906, no. 337; W.R. Valentiner, *Rembrandt, des Meisters Gemälde*, 1908, p. 533; C. Hofstede de Groot, *A Catalogue Raisonné of the Works of the the Most Eminent Dutch Painters of the Seventeenth Century, Based on the Work of John Smith*, 1908–27, vol. VI, 1916, p. 105, no. 137; W.R. Valentiner, *Rembrandt Paintings in America*, 1932, no. 103; A. Bredius, *The Paintings of Rembrandt*, 1936, no. 582; A.M. Frankfurter, "383 Masterpieces of Art," *Art N*, 38, 1940, p. 31, illus. p. 27; T. Borenius, *Rembrandt: Selected Paintings*, 1942, p. 13, fig. 16; W. Suida, *Catalogue of Paintings in the John and Mable Ringling Museum of Art*, 1949, no. 252

Tiziano Vecellio, called Titian
(ca. 1488–1576)

5. *Portrait of a Man, so-called Friend of Titian*, ca. 1550
Inscribed *Di Titiano Vecellio singolare amico*
Oil on canvas
35½ x 28½ in. (90.2 x 72.4 cm)

Fine Arts Museums of San Francisco, M. H. De Young Memorial Museum, Gift of the Samuel H. Kress Foundation, D61.44.17

PROVENANCE
Henry, Third Marquess of Lansdowne, Lansdowne House, London, by 1844, by descent to the Sixth Marquess of Lansdowne, London, sale, Christie's, London, March 7, 1930, no. 75, to Sabin; Frank T. Sabin Gallery, London; Mrs. E.S. Borthwick, Norton, London, sale, Christie's, London, May 15,

1953, no. 87; Koetser, London; Samuel H. Kress Foundation, New York, 1954, by whom given to the present owner

EXHIBITED
London, Frank T. Sabin Gallery, *Gems of Painting*, Summer 1937; Toronto, Art Gallery of Ontario *Titian, Tintoretto, Paolo Veronese*, February 12–March 13, 1960, no. 2, illus.

LITERATURE
A. Jameson, *Companion to the Most Celebrated Private Galleries of Art in London*, 1844, no. 52, as *A Venetian Portrait*, pp. 311, 290; G.F. Waagen, *Treasures of Art in Great Britain*, vol. II, 1854, p. 151; W.E. Suida, *Tiziano*, 1933, pp. 85, 163; J. Wilde, *Jahrbuch der Kunsthistorischen Sammlungen*, vol. VIII, 1934, p. 164, pl. 80; H. Tietze, *Tizian*, 1936, p. 186, pl. 207; J. Tancred Borenius, "Gems of Painting," *Burlington Magazine*, LXXI, July 1937, p. 41, illus. p. 40; B. Berenson, *Italian Pictures of the Renaissance: Venetian School*, vol. I, 1957, p. 190; W.E. Suida, *The Samuel H. Kress Collection*, 1955, pp. 16-17, illus.; *Art News*, May 1953, p. 8, illus.; F. Valcanover, *All the Paintings of Titian*, vol. III, 1965, pp. 13, 38, no. 46b, illus. pl. 46; F. Bologna, *Arte Veneta*, XI, 1957, p. 65; St. John Gore, "Five Portraits," *Burlington Magazine*, October 1958, p. 351–2; R. Pallucchini, *Tiziano: Lezioni...Universita di Bologna*, vol. II, 1954, p. 55–6; E. Gunter Troche, *The Art Quarterly*, XXVIII, 1965, 97ff; F.R. Shapley, *Paintings from the Samuel H. Kress Collection: Italian Schools*, vol. II, 1958, p. 184–5, illus. fig. 430; E. Larsen, "The Samuel H. Kress Collection at the M. H. de Young Memorial Museum," *Apollo*, LXI, June 1955, p. 174, illus. fig. II, p. 173; H. Comstock," Titian's Unknown Great Friend," *The Connoisseur*, no. 140, December 1957, p. 206, illus. p. 207; J. Walker, "Kress Collection and the Museums," *Arts Digest*, no. 29, March 1, 1955, p. 18; Clovis Whitfield, *Discoveries from the Cinquecento*, catalogue of the exhibition at Colnaghi, June 17–August 7, 1982, under no. 40; G. Pettrocchi, "Scrittori e poeti nella bottega di Tiziano," *Tiziano e Venezia, convegno internazionale di studi, Venice 1976*, 1980, p. 106; G. Reitlinger, *The Economics of Taste*, vol. 1, 1961, p. 467; B. Frederickson and F. Zeri, *Census*, 1972, p. 633; H. E. Wethey, *The Paintings of Titian: The Portraits*, vol. II, 1971, pp. 26, 102–3, no. 39, illus. fig. 91,92

Tiziano Vecellio, called Titian
(ca. 1488–1576)

6. *Portrait of Francesco Duodo* (1518–1594)
Oil on canvas
33 x 28½ in. (84 x 72.4 cm)

French & Company, Inc., New York

PROVENANCE
Probably Prince Trivulzio, Milan; Bonomi collection (inv. no. 106), Milan, until 1933 and thence by descent

LITERATURE
W. Suida, *Titian*, 1933, pp. 83, 166 and 187, illus. pl. CLXXb; G. Adriani, *Anton van Dyck: Italienisches Skizzenbuch*, 1940, p. 28, under no. 107 V

Tiziano Vecellio, called Titian
(ca. 1488–1576)

7. *Christ Crowned with Thorns*, ca. 1560–70
Oil on canvas
20½ x 16 in. (52 x 40.6 cm)

Private Collection

PROVENANCE
Private Collection; Derek Jones, London; Salander-O'Reilly Galleries, to the present owner

Jacopo Robusti, called Tintoretto
(1518–1594)

8. *The Raising of Lazarus*, 1573
Oil on canvas
27¼ x 31⅛ in. (69.2 x 79.1 cm)

Private Collection

PROVENANCE
Probably Procurator Gerolamo da Mula, Venice, who commissioned nine paintings from the artist on February 6, 1573 including a *Raising of Lazarus*; Sir George Lindsay Holford, Westonbirt, Gloucestershire, his sale, Christie's, London, July 15, 1927, no. 112; Viscount Rothermere, London; Dr. James Hasson, London and Kinswood, Surrey, until at least 1960; Thos Agnew and Sons, London; Kimbell Art Foundation, Fort Worth, sale, Sotheby's, New York, May 19, 1994, no. 49; Salander-O'Reilly Galleries, to the present owner.

EXHIBITED
London, New Gallery, *Venetian Art*, 1894–5; Budapest, National Museum, 1939–46; Manchester, City Art Gallery, *Art Treasures Centenary Exhibition*, 1957, no. 66; Norfolk, Virginia, King's Lynn, *Exhibition of Venetian Pictures*, 1959; London, Royal Academy of Arts, *Italian Art and Britain*, 1960, p. 38, no. 65

LITERATURE
H. Thode, *Tintoretto*, Bielefeld-Leipzig, 1901, pp. 110 and 139; J.B. Stoughton Holborn, *Jacopo Robusti called Tintoretto*, 1903, p.103; Mrs. A. Bell, *Tintoretto*, 1910, p. 44; R.N. Phillipps, *Tintoretto*, 1911, p. 159; F. Osmaston, *Tintoretto*, 1915, p. 188; E. von der Bercken-A.L. Mayer, *Jacopo Tintoretto*, Munich, 1923, vol. I, pp. 202, 203, 274, vol. II, p. 12; *The Holford Collection...at Westonbirt*, 1924, p. 68, no. 38, illus. pl. 56; M. Pittaluga, *Il Tin-*

toretto, Bologna, 1925, pp. 203, 272; M. Pittaluga, "L'Opere del Tintoretto smarrite o di malsicura identificazione," *L'Arte*, 1926, p. 140; A. Venturi, "Jacopo Tintoretto. L'esordio," *L'Arte*, 1928, pp. 170–80; E. von der Bercken, *Tintoretto*, 1942, p. 113, pl. 153; J. Lassaigne, *Tintoretto*, pl. 24; M. Tietze, *Tintoretto*, 1948, p. 376; R. Pallucchini, *La giovinezza del Tintoretto*, 1950, p. 152; B. Berenson, *Italian Pictures of the Renaissance:Venetian School*, vol. I, 1957, p. 178; P. de Vecchi, *L'opera completa del Tintoretto*, 1970, p. 114, no. 207; *Kimbell Art Museum, Catalogue of the Collection*, 1972, pp. 40–43; R. Pallucchini, "Una Nuova 'Resurrezione di Lazzaro' di Jacopo Tintoretto," *Arte Veneta*, v. 31, 1977, p. 100, fig. 5, p. 101; J.D. Morse, *Old Master Paintings in North America*, 1979, p. 262; *Kimbell Art Museum Handbook of the Collection*, Fort Worth, 1981, illus. p. 137; R. Pallucchini and P. Rossi, *Tintoretto: le opere sacre e profane*, 1982, pp. 127, 199, no. 327, fig. 424; P. de Ticozzi, *Imagine del Tintoretto. Stampe dell'XVI al XIX secolo*, 1982, under no. 24; *In Pursuit of Quality: The Kimbell Art Museum*, 1987, p. 180, illus. in color; T. Nichols, *Tintoretto: Tradition and Identity*, 1999, pp. 106, 107, illus. in color. p. 108, fig. 89

Jacopo Robusti, called Tintoretto (1518–1594)

9. *Self-Portrait*, 1546–48
 Oil on canvas
 17¾ x 15 in. (45 x 38 cm)

Philadelphia Museum of Art, Gift of Marion R. Ascoli and the Marion R. and Max Ascoli Fund in honor of Lessing J. Rosenwald 1983-190-1

PROVENANCE
Norton Collection, Boston; Wildenstein, New York; Max Ascoli, New York by whom given to the present owner

EXHIBITED
Paris, Grand Palais, *La Siècle de Giorgione et de Titien*, March 9–June 14, 1993; Venice, Accademia, *Tintoretto*, March 26–July 10, 1994 and Vienna, Kunsthistorisches Museum, July 31–September 30, 1994

LITERATURE
R. Pallucchini, *La Giovinezza del Tintoretto*, 1950, pp. 117–18; B. Berenson, *Italian Paintings of the Renaissance: Venetian School*, vol. I, 1958, p. 182; P. de Vecchi, *L'Opera completa del Tintoretto*, 1970, p. 92, no. 62b; P. Rossi, *Tintoretto: i ritratti*, 1982, p. 97, no. 101, illus. fig. 9

Jacopo Robusti, called Tintoretto (1518–1594)

10. *Portrait of a Man*, 1546–48
 Oil on canvas
 23 x 17¾ in. (58.4 x 45 cm)

Private Collection

PROVENANCE
Woodner Family Collection; Stanley Moss, Riverdale, New York; Salander-O'Reilly Galleries, to the present owner

LITERATURE
R. Pallucchini and P. Rossi, *Tintoretto: Le opere sacre e profane*, 1994, vol. I, p. 235, no. R.2, vol. II, fig. 602

Jacopo Robusti, called Tintoretto (1518–1594)

11. *Man of Sorrows*, ca. 1545
 Oil on canvas
 35 x 34½ in. (89 x 87.5 cm)

Private Collection

PROVENANCE
Possibly Bacchio, Venice; Private Collection; Marco Grassi, New York; Salander-O'Reilly Galleries, to the present owner

Paolo Caliari, called Veronese (1528–1588)

12. *Christ Crowned with Thorns*, 1582–85
 Oil on canvas
 29¾ x 22½ in. (75.5 x 57 cm)

Piero Corsini, Inc.

PROVENANCE
David Carritt, London

LITERATURE
F. Pedrocco & T. Pignatti, *Veronese: Catalogo completo dei dipinti*, 1991, p. 316, no. 248; F. Pedrocco & T. Pignatti, *Veronese*, 1995, vol. II, p. 485, no. 386

PHOTO CREDITS

Alinari/Art Resource, fig. 3; Archivio Camer-
aphoto Venezia, fig. 20; J.G. Berizzi, fig. 2; Erich
Lessing/ Art Resource, figs. 6, 7, 11, 12; Ralph
Lieberman, fig.18; RMN—Gérard Blot, fig. 13;
Scala/Art Resource, figs. 21, 22, 23; John Stoel,
fig. 24; Malcolm Varon, plate 1; Paul Waldman,
plates 7, 8, 10

ISBN: 1-58821-084-7

Design: Lawrence Sunden, Inc.
Printing: The Studley Press